BLACKWOOD & AROUND

THROUGH TIME

Ewart Smith

AMBERLEY PUBLISHING

First published 2013

Amberley Publishing
The Hill, Stroud, Gloucestershire, GL5 4EP
www.amberley-books.com

Copyright © Ewart Smith, 2013

The right of Ewart Smith to be identified as the
Author of this work has been asserted in accordance with
the Copyrights, Designs and Patents Act 1988.

ISBN 978 1 4456 3308 4 (print)
ISBN 978 1 4456 3325 1 (ebook)

British Library Cataloguing in Publication Data.
A catalogue record for this book is available from the
British Library.

Typesetting by Amberley Publishing.
Printed in Great Britain.

Introduction

With local place names such as Maesrhuddud, Penllwyn, Bedwellty, Mynyddislwyn, Gellihâf, Cwmnantyrodyn, Gwrhay, Rhiw Syr Dafydd, Pentwyn, Croespenmaen and Gelligroes, there is no doubt that Blackwood and its environs were, at one time, 100 per cent Welsh. The advent of the iron and coal industry at the head of the valley changed all that; but more particularly, perhaps, it was the construction of the Sirhowy Tramroad, linking Tredegar with Newport, that did so. This tram road enabled iron bars, rails and rods to be transported from their place of production to a port. The railroad opened in approximately 1805. Prior to that, the iron produce was taken south by mule along the ridge from Tredegar coming into the Sirhowy Valley at Gelligroes. There was no route down the valley near river level until the tram road was built. Part of this new route was through a sizeable *coed duon*, or black wood, and it was here that the town of Blackwood would grow into the main concentration of population between Newport and Tredegar.

Much of the early development of Blackwood must be attributed to John Hodder Moggridge, an Englishman from Gloucestershire who bought the 450-acre Rhos-newydd estate from Miss Mary Morgan – the last of the ubiquitous Morgan family. Moggridge devised a plan whereby he would offer grants of one eighth of an acre of land to local workmen for a term of three generations on condition that

1. The tenant would pay a regular but reasonable rent for the ground.
2. The tenant would build a cottage, with help if necessary, and on the understanding that his efforts did not interfere with his normal work.
3. Any money advanced by Moggridge would be repaid in instalments at regular intervals, the loan to be secured by the cottage.

His idea was that family life would centre around each cottage, and so the workforce would be less likely to want to leave the area. Another big plus for the workers was that they would be able to grow their own fruit and vegetables. Moggridge lived in Woodfield (one of the first English place names in the area) and decided his 'experiment' should be on the other side of the river, i.e. in the Black Wood that straddled the tram road. The project took a while to get off the ground, but by 1822 almost forty plots had been leased.

As the 1881 census shows, people continued to pour into the area from England. They came principally from Somersetshire, Herefordshire and Gloucestershire, but some were from as far

afield as Devon and Cornwall. In particular, the businessmen and professionals tended to be English, so English was the dominant language with the upper strata of society. Quite naturally, this resulted in English becoming the language of the whole community. The colliery manager, watch and clockmaker, newsagent, blacksmith, a boot and shoe maker and rail inspector all came from Somerset; the governess from Bristol; the police sergeant, farm bailiff, another boot and shoe maker, and one of the main drapers from Gloucestershire. On the other hand, the vicar came from Glamorgan, the curate from Carmarthen, the headteacher from north Wales, the station master from Pembroke, and the grocer from west Wales, but English may have been the first language of some of these. Inter-marrying also diluted the amount of Welsh spoken, for example my mother was Welsh-speaking but my Blackwood-born father spoke only English. The result was that English only was spoken in the home, as was the case in the schools and most chapels. The larger the village grew, the more anglicised it became. Recently, I have asked several people who have lived in the town all their lives a question: 'Have you ever heard a conversation in Welsh as you have walked along Blackwood High Street?' The answer has, in every case, been 'no'.

These facts probably give some indication why the area originally called Coed Duon became known as Blackwood. Great effort is being made, and much money is being spent, to try to reintroduce the Welsh language to the local population, but the language faces tremendous obstacles, for it is a fact that English is rapidly becoming the language of the world – with English pounds and US dollars one can travel almost anywhere.

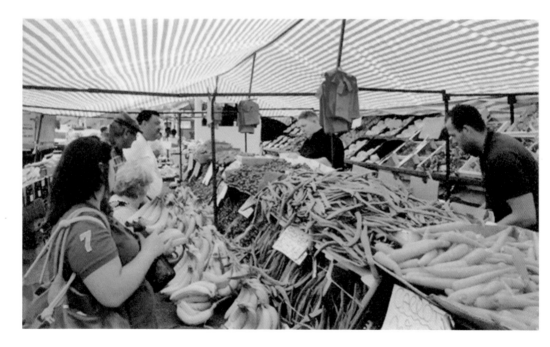

Blackwood Market
The principal fruit and vegetable stall in Blackwood Market, as you approach the market square from the centre of the High Street. Always colourful, always busy, always noisy with the pitching of the vendor, it serves the community well every Tuesday, Friday and Saturday.

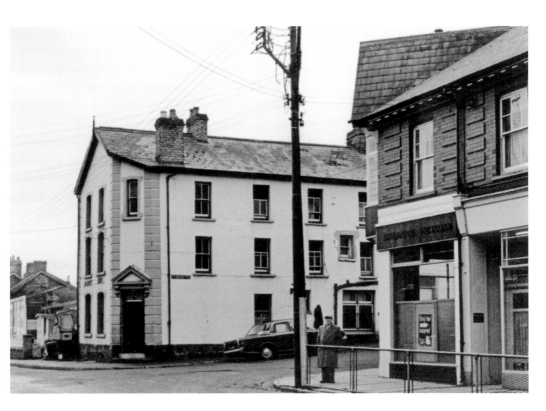

The Parrot Hotel

The Parrot Hotel was the largest hotel in the town and the centre of much social activity. When it ceased to be needed, it was replaced by a modern library which, in 2012, was refurbished, with much more emphasis on providing for children and young people than had hitherto been the case.

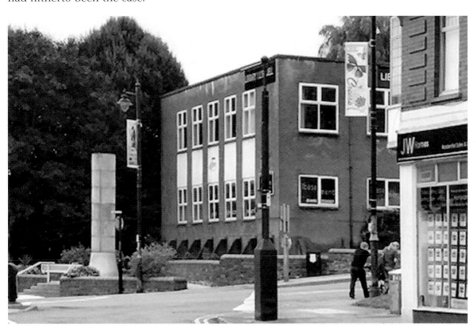

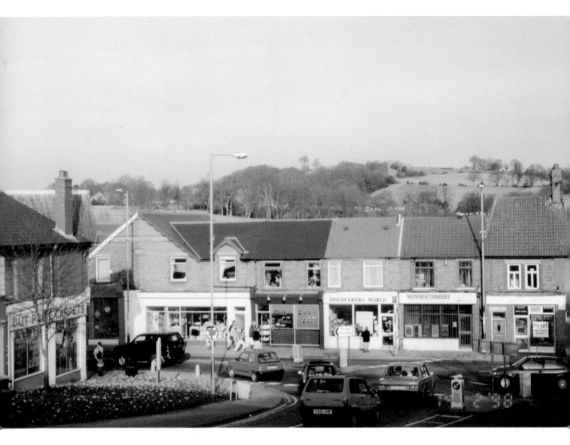

Blackwood West End

Almost all of the properties seen here just north of the town library have undergone a change of use in recent years. It is good to see that Ystrad Mynach College now has a base in the town.

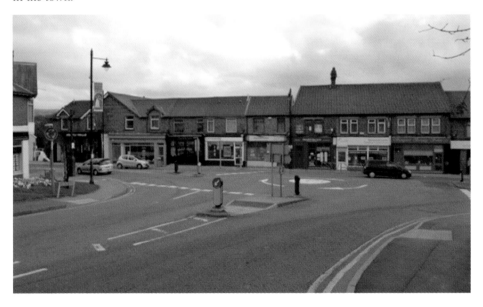

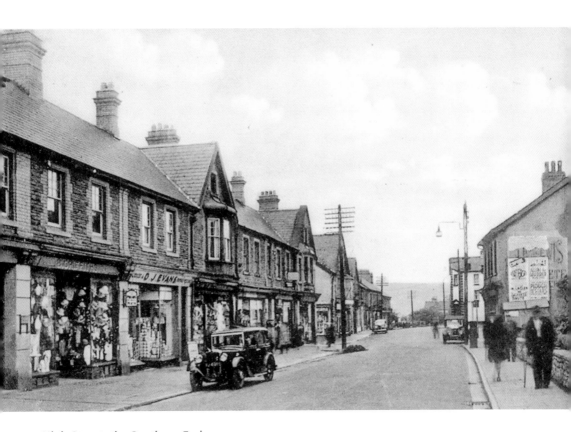

High Street, the Southern End

Looking south from a point outside what was, until 2012, the post office. The Parrot Hotel is visible to the right. On the opposite side of the road, the building on the southern side of the junction was demolished to widen the entrance to Bridge Street, and thus give better access to the car park behind the High Street.

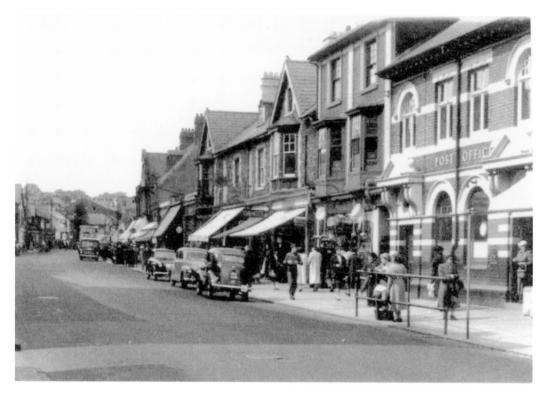

The Central High Street

The post office, opened in the 1920s as a crown office, is now Zaks. The bus stands have been removed – there is now a purpose-built bus station on the western side of the High Street. Traffic calming has been introduced in an effort to make the High Street less attractive to through traffic, and provide a safer environment for pedestrians.

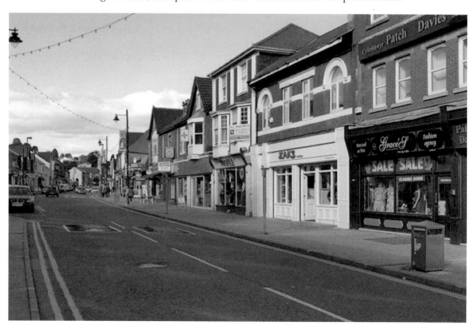

Gravel Lane

These photographs show the busy link between the High Street and the market square and bus station. In the twenty years between the two pictures, all the businesses have changed hands.

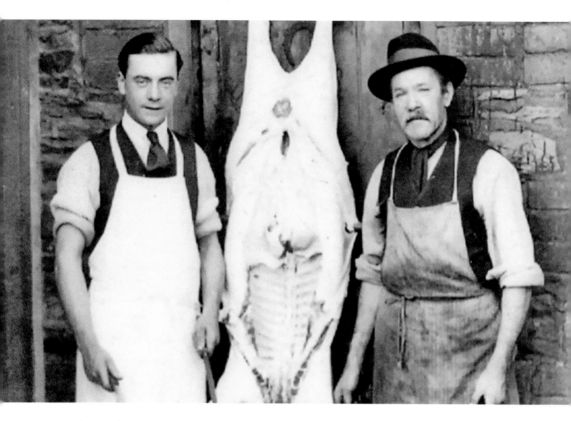

The Precinct

The High Street butcher's was once the slaughterhouse behind Woodwards but is now a pleasant part of the precinct. This section runs parallel to the High Street but is inaccessible to the general public outside business hours.

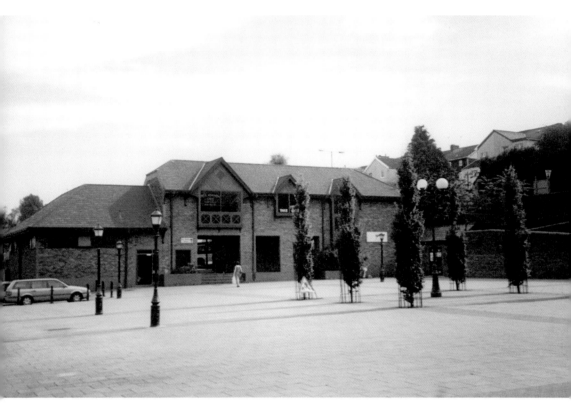

The Market Square

The market square viewed from the north, looking towards the bus station. When the area was redeveloped earlier in the century, the main building, which housed a café, retail units and public toilets, was removed and replaced with a far superior, user-friendly structure.

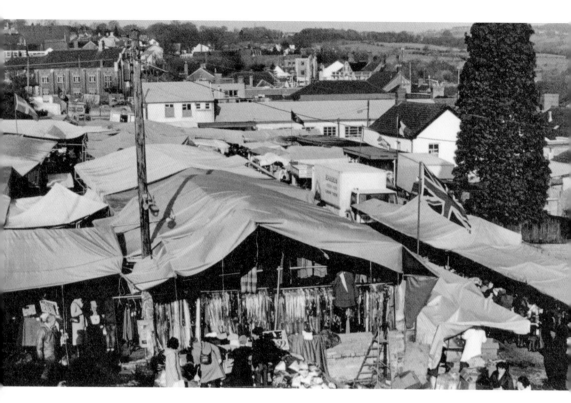

Market Day

Blackwood has always possessed a prosperous market. These pictures show how it has evolved over the past fifty years. Today's stalls sell fruit and vegetables, flowers and plants, rugs and carpets, meat, clocks and watches, knitwear, sweets and confectionery, and general goods. The market is open three days a week: Tuesday, Friday and Saturday.

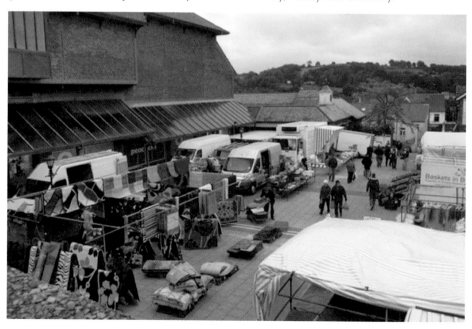

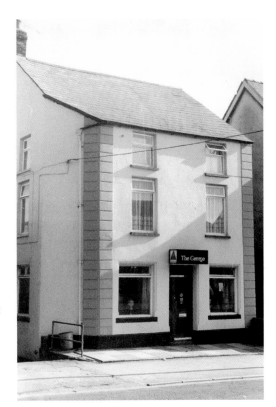

The Coed Duon

Formerly The George, and one of the oldest hotels in the town (it is shown on an old map dated 1822), it has been renamed the Coed Duon (meaning Black Wood) in recent times. The front was extended in the early 1990s, and it has had another revamp more recently. It was at this spot that the Vulcan steam engine blew up in April 1843, killing three people. In those days, the tramway passed through the centre of the town.

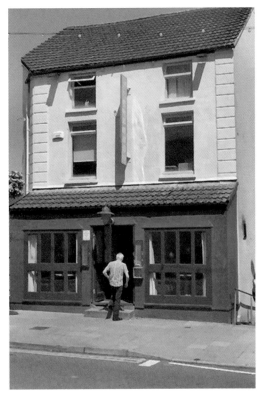

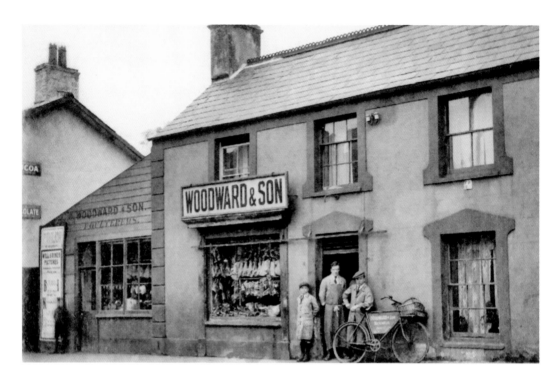

The Yew Tree

Woodward & Son's building was completed in 1823, the lean-to alongside probably being used as a stable for horses. In the early days, the property was a beer house known as the Yew Tree. In the latter part of the nineteenth century it became a butcher's shop, and remained so until Woodward's closed late in the last century. Today the property is used by Woolleys (florist), Edwards (travel) and Get Connected (mobile phones).

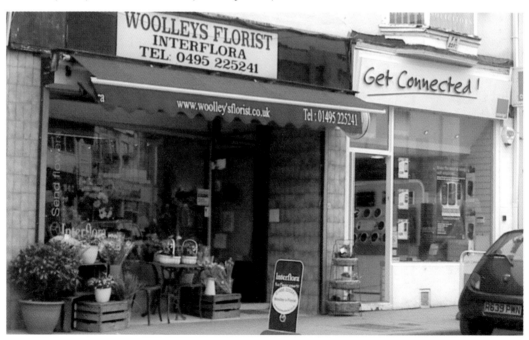

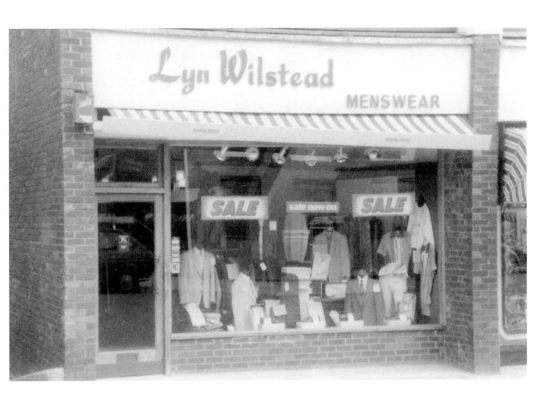

The Original Market Site

The post-war buildings on the opposite side of the road from Woolleys stand on the original site of the town market. Lyn Wilstead's menswear shop moved here from a smaller property opposite. It has been replaced by the Card Factory, a business giving very good value for money in birthday and anniversary cards.

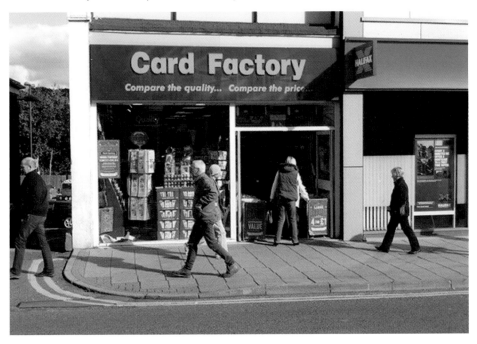

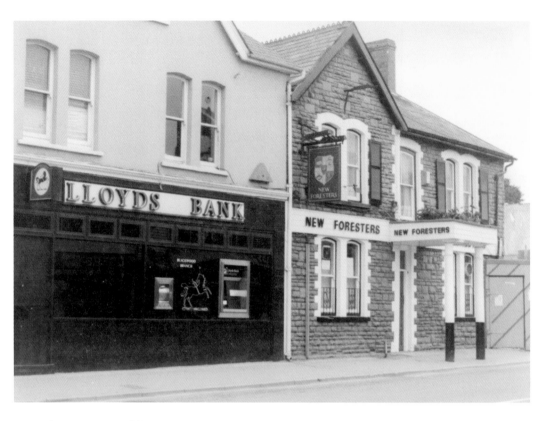

The Foresters Public House

Conspicuous by its pillared porch, this old hotel is aptly named as it would have been in the middle of the big, black wood the town was named after. Once the Foresters, then the New Foresters, and now back to its original name, it stands adjacent to Lloyds Bank, which has been refurbished yet again.

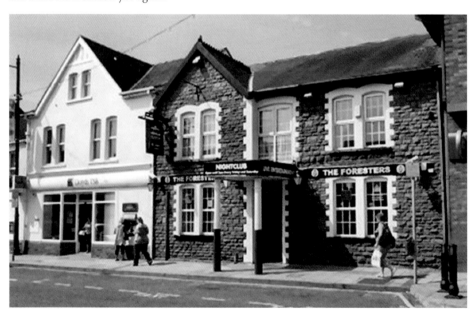

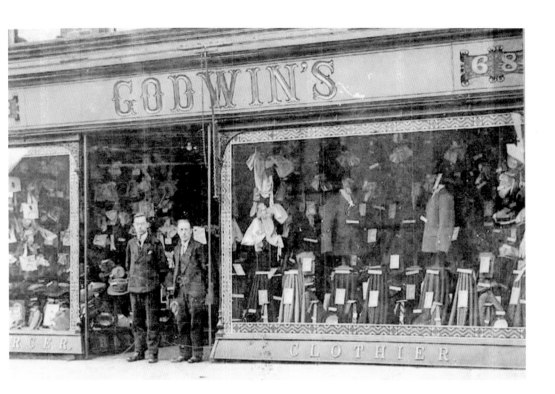

Godwin's Menswear

During the period immediately following the Second World War, Godwin's was the premier gentlemen's fashion shop in the town. Subsequently it became Bollom's the drycleaners, but was removed when the new precinct was developed. The lower photograph shows a route to the market square between Thomas Cook and Boots; the occasion was the annual fair day when the High Street was closed to traffic.

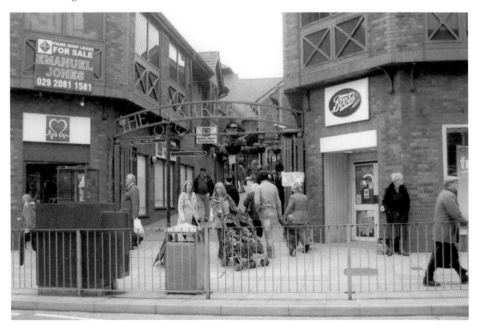

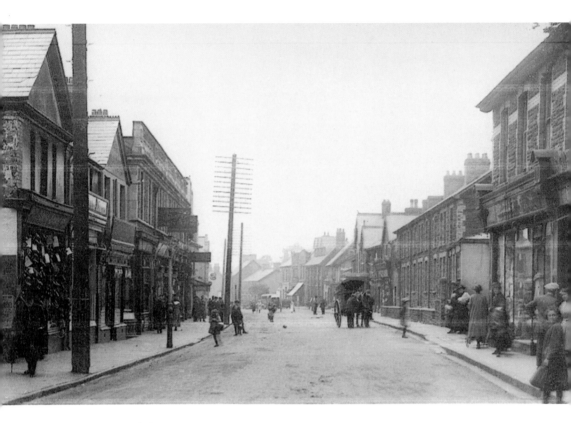

Blackwood High Street

Looking south along Blackwood High Street near its intersection with Woodbine Road. In the upper picture, note the balustrade above the London Hosiery building. This was removed many years ago because it was dangerous and had caused dampness in the building. The entrance to Woodbine Road was originally a lane: Morris Lane.

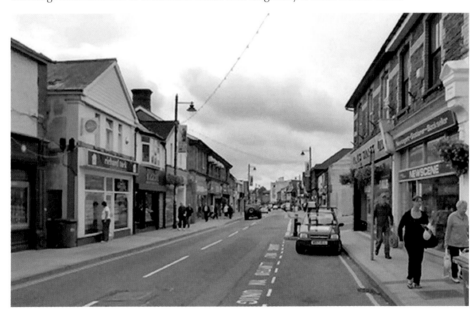

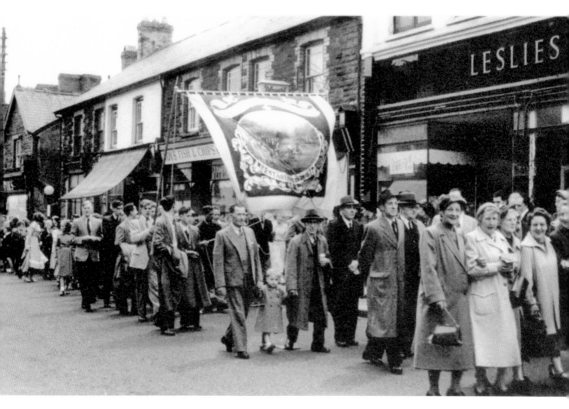

Leslie's Stores

Members of Mount Pleasant Baptist church passing Leslie's Stores, later Poundstretcher, on Blackwood High Street in the 1950s. The building was destroyed by fire in the summer of 2013 and the site awaits redevelopment.

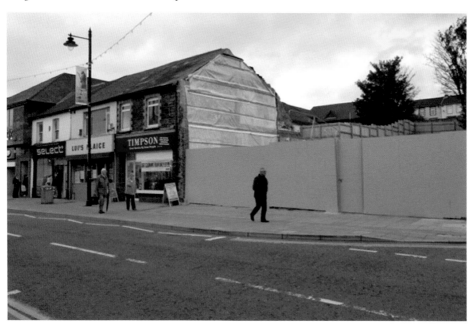

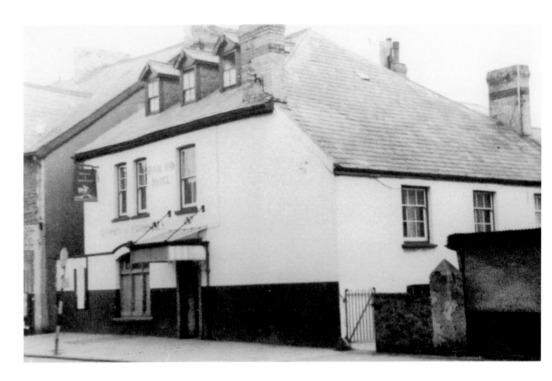

The Royal Oak

The main access to the Royal Oak, another very old public house with living accommodation beneath, was from the High Street. From the early 1830s to the 1950s, the south aspect overlooked the market area. Several shops now occupy this site. Part of Shaws, originally a grocer's, provided an alley to a bakery behind.

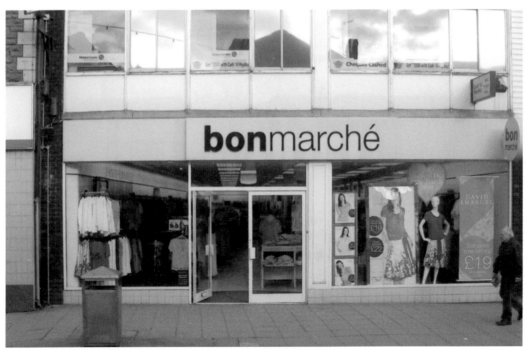

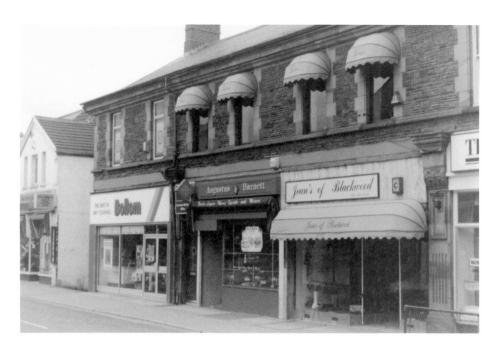

The London Hosiery

This block was originally known as A. P. Hughes, a large store selling drapery and millinery. He sold out to The London Hosiery Company and put up the money to open Jones & Richards, 'the fashion centre of the valleys', in the building now occupied by Gus Jones, the jeweller's. When the London Hosiery closed, the property was divided into three units, the 2013 occupants being shown below.

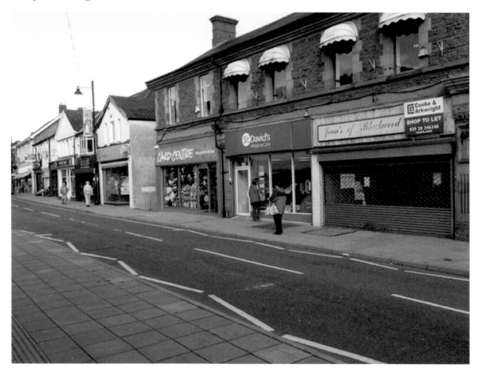

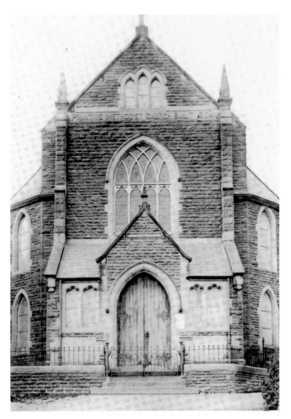

The Little Theatre
Formerly the Primitive Methodist church, known locally as the Prims, the building was used as a storage depot and Air Raid Precautions meeting point during the Second World War. Becoming redundant after the war, it was purchased by Blackwood Dramatic Society, who converted it into the Blackwood Little Theatre. Fitted out with second-hand cinema seats, the society staged four productions a year, the principal driving force being their general secretary Charlotte Powell MBE.

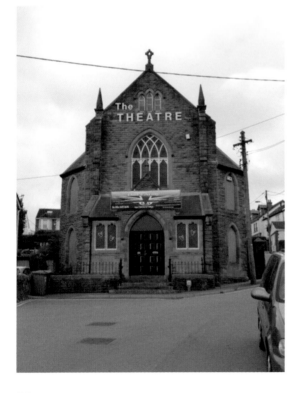

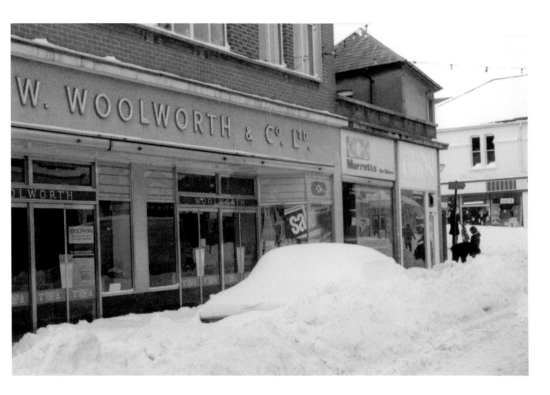

The F. W. Woolworth Site

When F. W. Woolworth & Co. Ltd came to Blackwood to occupy the site from which Glanfrwyd House had been cleared, Tidal's Store was forced to change from Blackwood's unofficial 'Woolworths' into a furnishing business. It was a shock when Woolworths closed nationwide. Its outlets were sold to several different companies, and Blackwood was fortunate enough to gain a Poundland in its place – a move that has proved very popular with the locals.

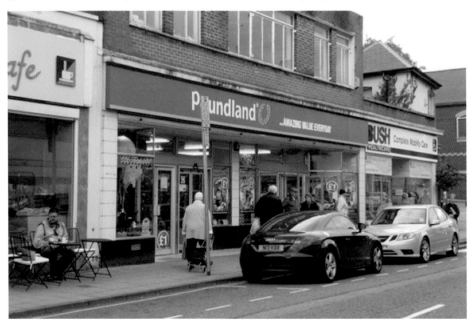

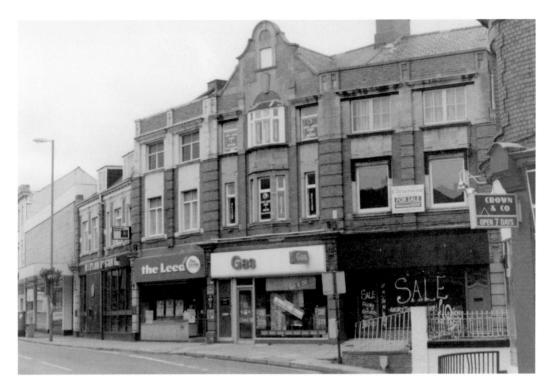

The Square

One of the oldest large retail blocks in the town. The Leeds Building Society became Halifax and moved south along the High Street to a more central position, moving yet again in 2013. The Gas Showroom transferred to the new precinct, spent a few years there and closed, since which time this excellent site has remained vacant. Other parts of the block are occupied by HSBC, Q Studio, Robert Barker, a cancer charity shop, an optician and a café.

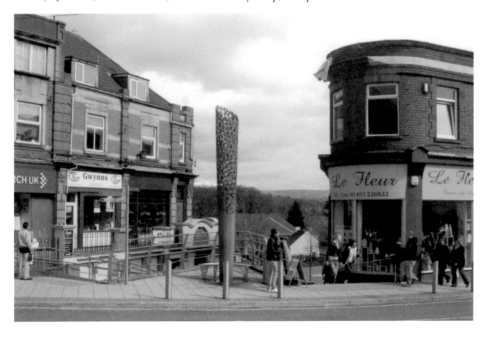

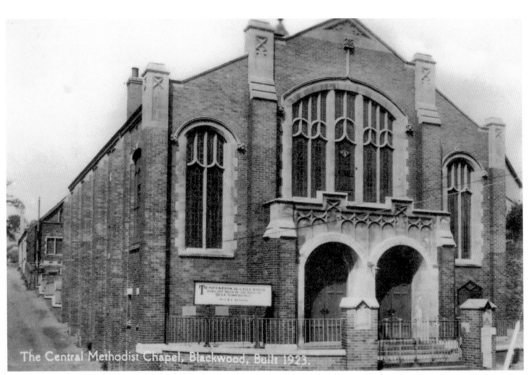

The Central Methodist Chapel, Blackwood, Built 1923.

The Central Methodist Church Looking west from The Square towards the Central Methodist church, which was built in 1923. The approach was completely restructured in 2013, as can be seen from the photograph below. The work included providing wheelchair access and two pairs of impressive see-through doors.

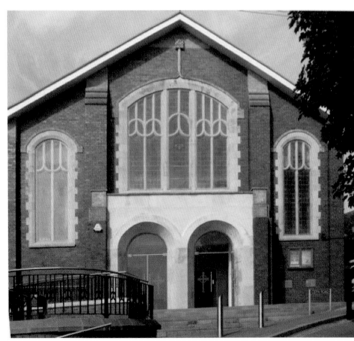

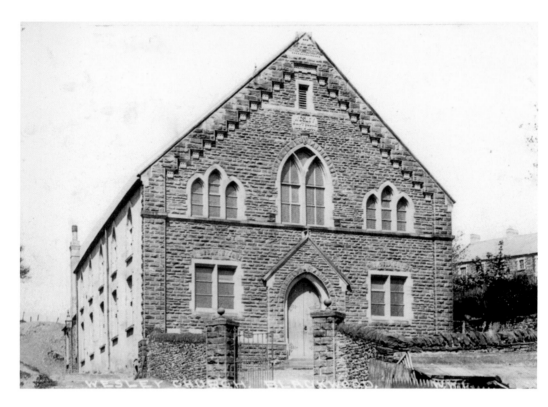

The Wesley Chapel
Originally on a site behind the Central Methodist church, the Wesley chapel was erected in 1898 and was the third such chapel to be built in the vicinity. It was used until 1915, when it was destroyed in a fire. The site is now occupied by Islwyn Community Credit Union.

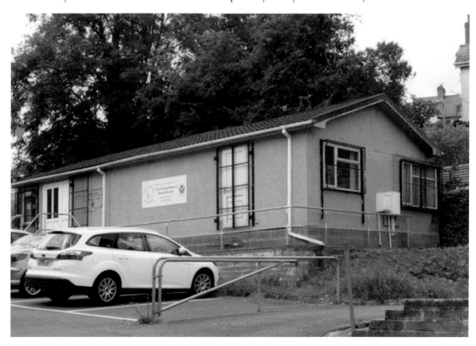

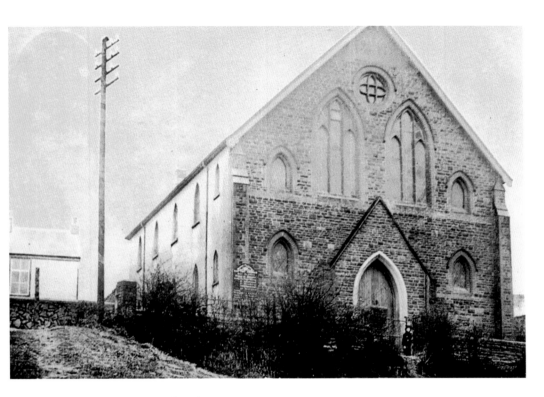

Mount Pleasant Baptist Church

A short distance up Cefn Road from the Methodist church stands Mount Pleasant Baptist church. This church was built in 1891/92 at a cost of £1500, and still thrives today. A school room was added at the rear in the 1930s, while the building was re-roofed, re-rendered and extended in recent times.

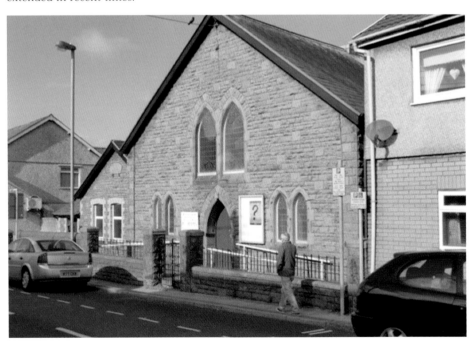

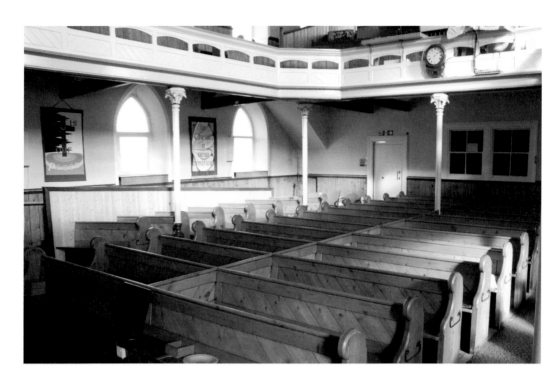

Mount Pleasant Baptist Church, the Interior

These photographs show the refurbishment inside Mount Pleasant Baptist chapel. Out have gone the dark, heavy pine pews, to be replaced by comfortable padded chairs, some with arms. Also gone is the big seat and the pulpit. Hymn books are no longer used; the hymns come up on a screen, while the microphone at the front allows everyone to hear what is being said from the dais. Moveable chairs mean that the space now permits multi-purpose use.

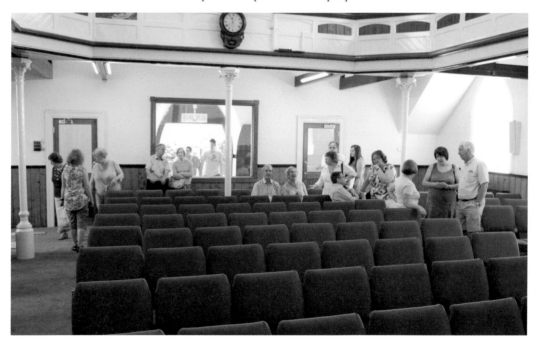

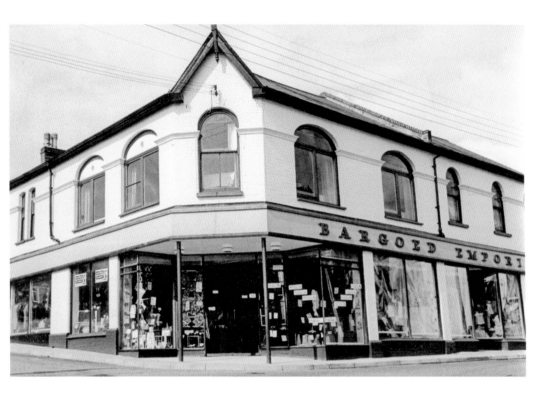

The Bon Marché
This building, variously known as Powell & Jones, Bon Marché, The Bargoed Emporium and Stevens Value, was one of the most important drapery and household wares businesses in the town. Stevens Value was destroyed by fire in 1987, subsequently rebuilt in a similar design, and opened as the local Argos. This is one of the most well patronised stores in the town.

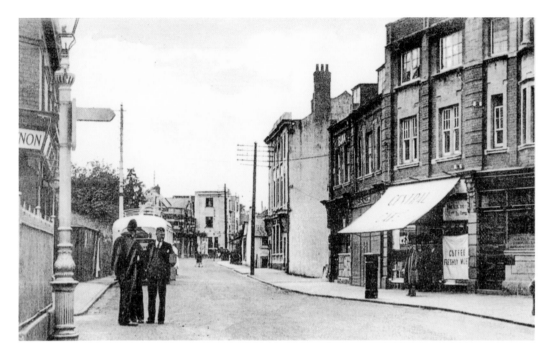

The Financial Area

The upper picture shows Wick Thomas's Central Café, with the letter box outside. This is the postbox where Iris Watkins posted her letters on that fateful night in August 1925. She was never seen alive again and her death has forever remained a mystery. Further along were Burgess (jewellers), the Midland Bank, the Crown public house (set back and out of view), Barclays Bank and the Miners' Institute. The Midland has become HSBC and doubled in size, and the gap originally housing Tesco's is now Twenty One, while Barclays is relatively unchanged, except that the manager does not live 'over the shop'.

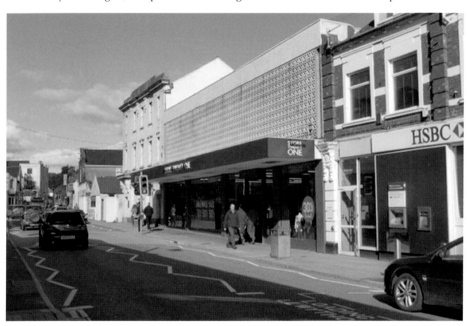

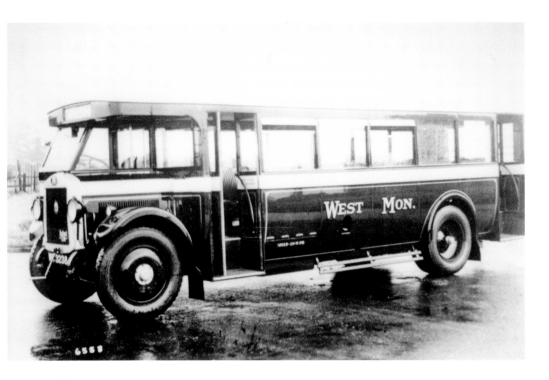

Local Transport

The local councils, Bedwellty and Mynyddislwyn, operated a bus company, the West Monmouthshire Omnibus Board, from 1926 to 1974. One of their early buses, with doors at the front and the rear, and adorned in maroon and cream, is shown here. The driver was totally isolated from his passengers, unlike today, for it was a conductor who collected the fares. The lower picture shows a modern Islwyn Borough Transport single-decker standing in Blackwood bus station.

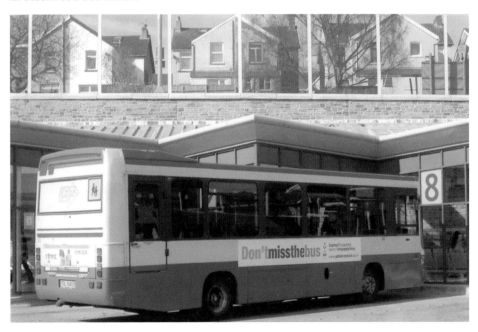

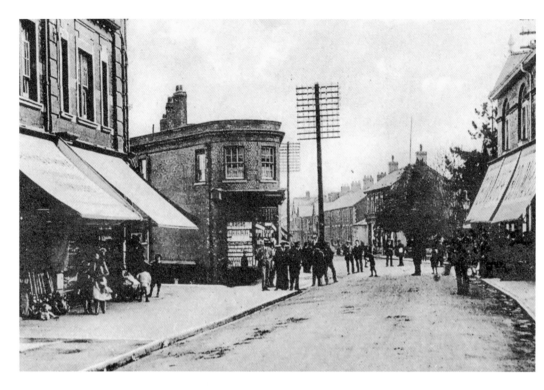

The Square

From The Square looking south, illustrating how the presence of people has given way to traffic. The telegraph wires have disappeared underground and street lighting is much improved. The road from Hall Street on the left has been blocked off in an attempt to reduce the amount of traffic on the High Street.

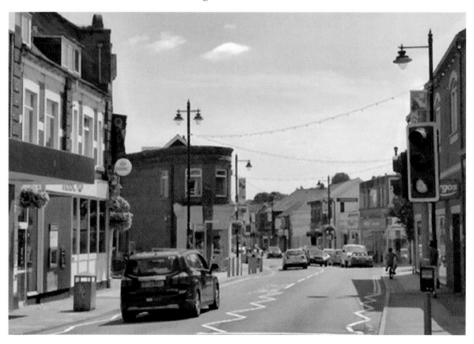

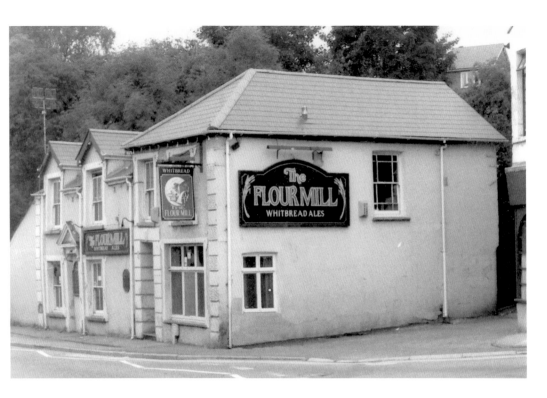

The Tredegar Arms

Cyril Bounds, the gents hairdresser, used to run his business in the room on the corner with two windows, the window to the right being the entrance. Variously known as The Mill, the Tredegar Arms, and the TAs, its present name is The Flourmill, which takes us back to what it was originally known as. This building has undergone major restructuring in 2012/13. It is now described as a cocktail bar serving food.

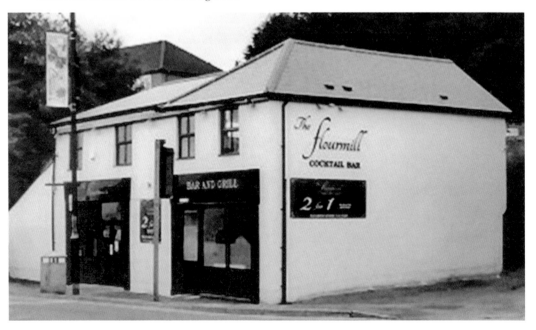

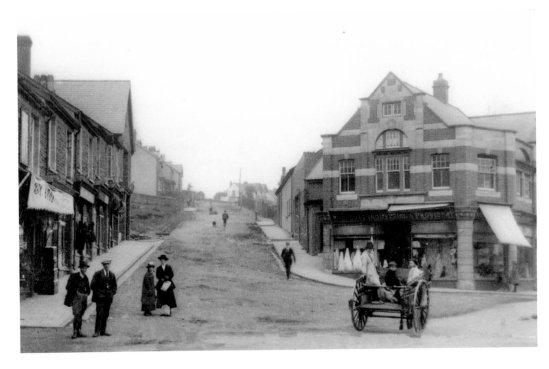

Pentwyn Hill

The view up Pentwyn Road before the cenotaph at the top of the hill was erected. It reveals a much slower pace of life, when people could stand in the middle of the road and talk. Major changes have taken place to the Co-operative building on the right. The open space partway up the hill on the left became Chaston's main motor workshop. It is still a servicing garage today.

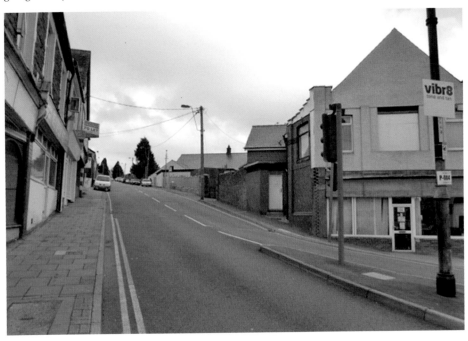

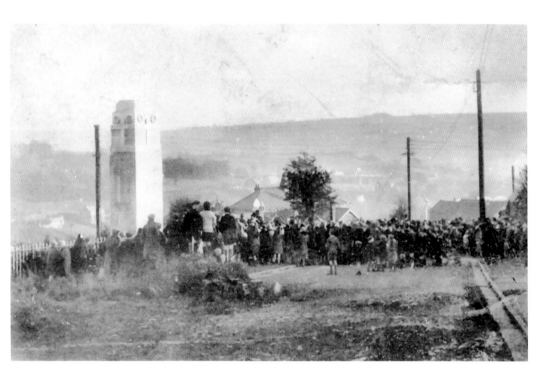

Unveiling of the Cenotaph

Crowds gather to witness the unveiling and consecrating of the war memorial, commemorating those men of the town who had given their lives for King and Country in the First World War. Little did the participants think the process would be repeated some thirty years later. The memorial has been railed off from the south and the entrance is now on the western side.

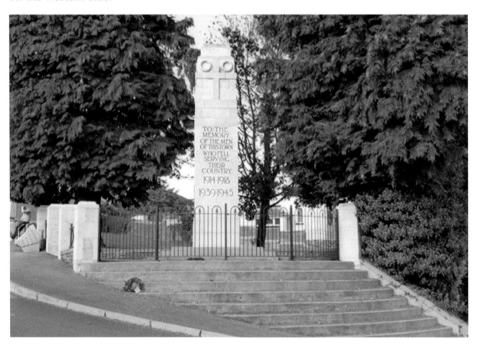

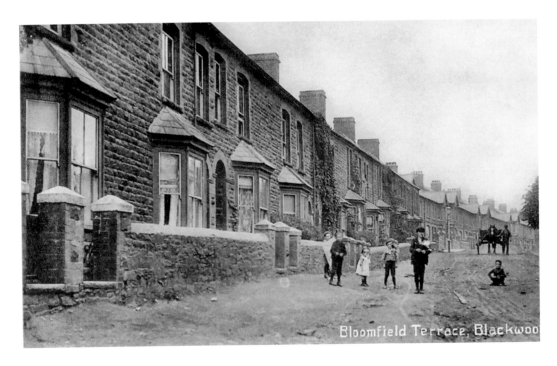

Bloomfield Terrace

Bloomfield Terrace, at the bottom end of Bloomfield Road. Little has changed except that children no longer play in the earth of an unmade road. These days, the preferred mode of transport is the motorcar rather than horse and cart. On the land to the right, Bloomfield House, once the home of Christopher Pond, the coal owner, has been incorporated into the local authority Beatrice Webb residential home.

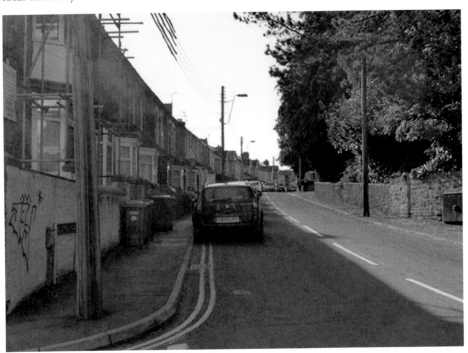

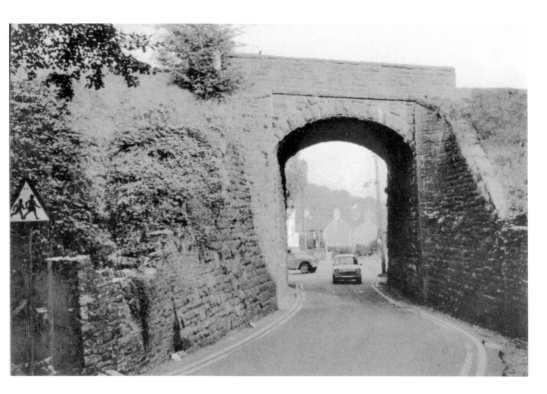

Hall Street Bridge

Looking from the town end of Hall Street through the railway arch towards Glanyrafon Park. The bridge, built in the 1860s, carried the railway line along the Sirhowy Valley. In the 1980s, some years after the line had closed, it was taken down to widen the road.

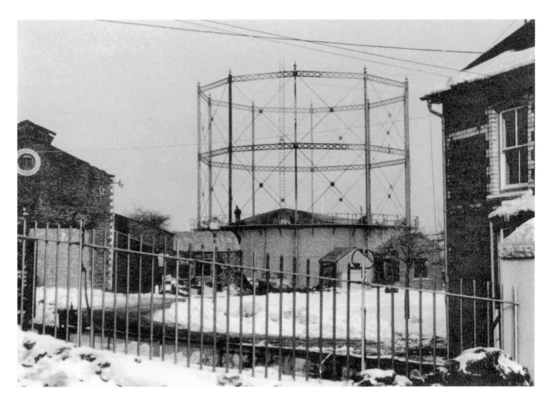

The Gasworks

The gasworks and holder at the southern end of Hall Street. This gasworks opened in July 1891. Previously a small gasworks had operated from the ground, now a car park, to the rear of Tidal's Store. It now belongs to Blackwood Rugby Club and the former gasworks land is the site of their new clubhouse.

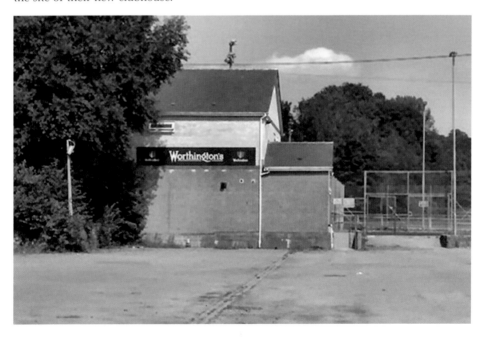

William Street Car Park

Looking towards Pontllanfraith along the rear of William Street from the railway embankment, before the large car park on the eastern side of the High Street was built, and before vegetation separated the lane from the top of the embankment. Cars cannot enter or exit at this end.

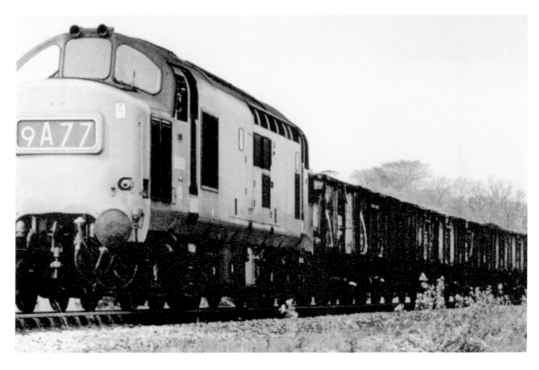

The Last Days of Coal in the Valley

One of the last coal trains down the valley on the eastern side of the High Street in 1964. The line was subsequently converted into a car park, with several short paths linking it to the nearby shops. A new retail park now functions at the northern end.

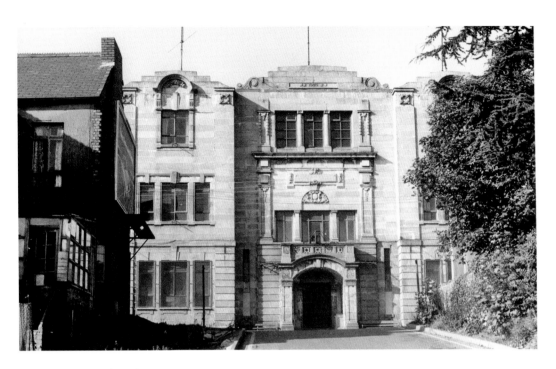

The Miners' Institute

Blackwood Miners' Institute, which was paid for by the local miners. The reading room on the left was where the daily newspapers could be read, while there was a good library on the ground floor on the opposite side of the building. The main facility on the first floor was the hall with its beautiful Canadian maplewood floor. There was a stage at the west end, which allowed musicals and dramas to be performed. Now owned by the Caerphilly Council, the building is still an important centre of social activity.

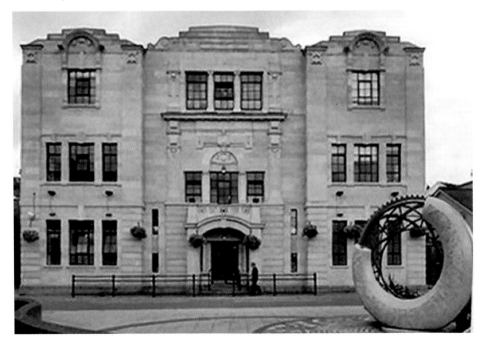

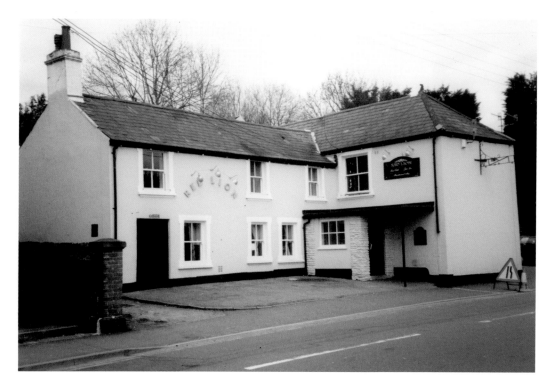

The Red Lion

A favourite haunt where young men often gained confidence before proceeding to the dance floor in the Institute next door. Today, the foreground on the opposite side of the main road sports a pleasing piece of modern art. The extended, though at present unused, Red Lion stands behind.

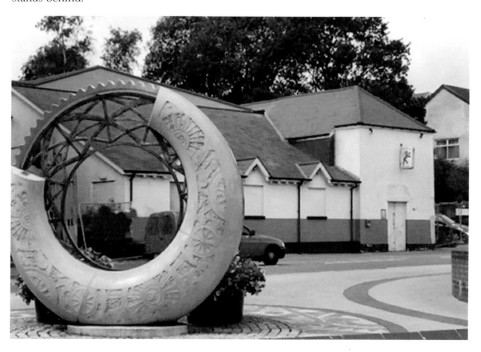

Rock House

This was the home of the Chaston family, owners of the main motor dealership in the town. Attached to Rock House was a terrace of low-ceilinged cottages, whose front doors opened onto the pavement. Today the scene is quite different. In their place are ASDA's staff smoking shelter and a new block of flats, while Harold Richardson's former station garage has become Homestyle, a centre selling beds and carpets.

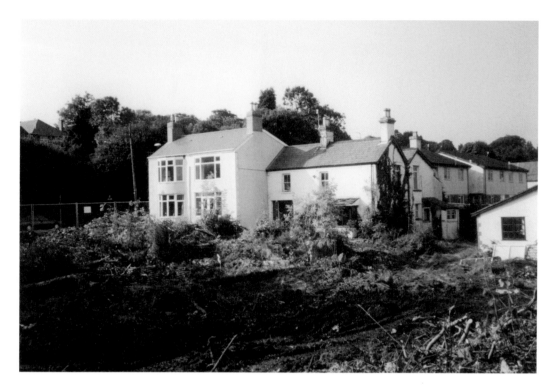

The ASDA Supermarket
Rock House from the south as the area was being prepared for the ASDA supermarket. While staff can access the building from the main road, shoppers are invited to descend several flights of steps, or take a winding San Francisco-like walkway, to access the building on the opposite side of the complex.

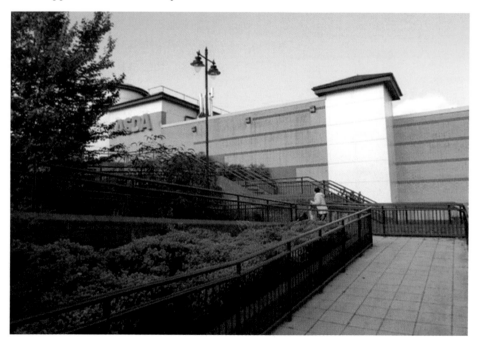

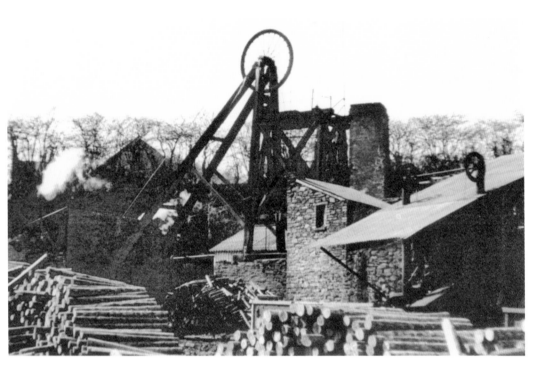

Budd's Colliery

Known both as Budd's Colliery and the New Rock Colliery, this small but deep mine employed as many as seventy men in the early 1950s, producing house gas, bunker and industrial coals. It closed in 1957. Now Aldi's car park, the lower photograph shows the former Blackwood Junior School on the elevated ground behind the trees, and the Drill Hall and Girl Guide hut to the left.

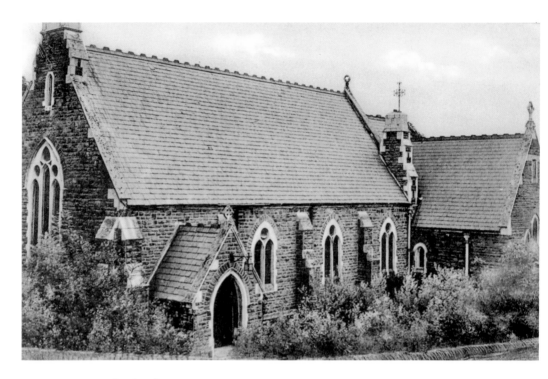

St Margaret's Church

The south-west corner and main entrance to St Margaret's church, Blackwood. Dedicated to St Margaret of Antioch, the church was built in 1876, extended in 1891, and had its vestry added in 1960. In modern times, a new church hall has been erected to the north of the main building, in place of the one formerly standing on Hall Street. Various grants have enabled facilities at the hall to be improved significantly in recent times.

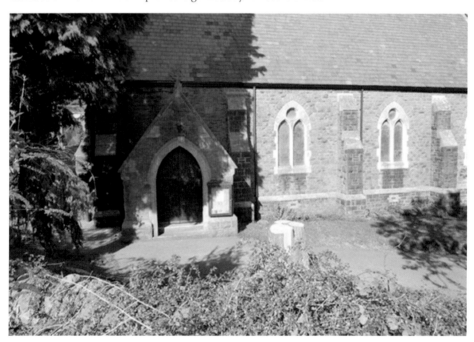

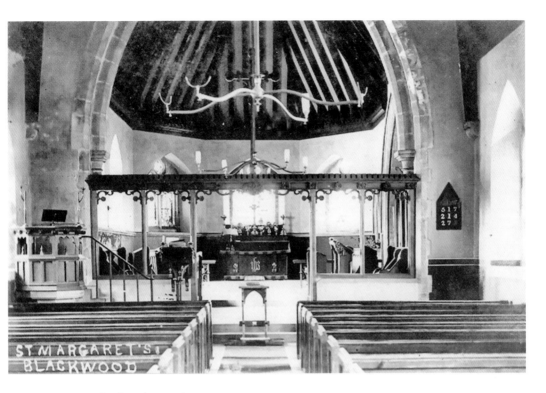

St Margaret's Church, Interior

These pictures show how the interior of St Margaret's church has changed from the 1920s to the present day. The old gas lighting has gone, while the pulpit, pews, reading desk and hymn board have all been upgraded. The two photographs suggest that there has always been a problem with penetrating damp around the area of the chancel arch.

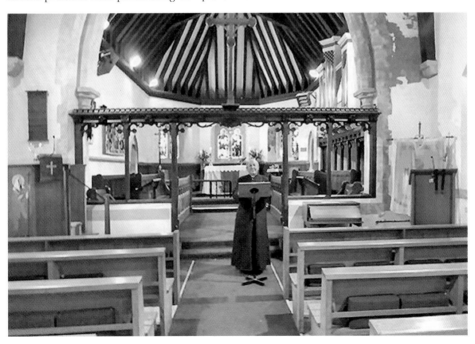

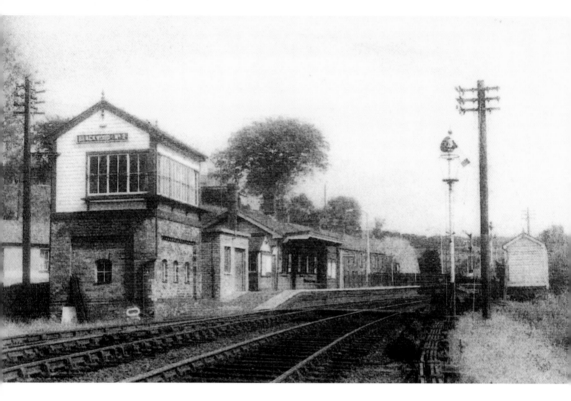

Blackwood Railway Station

This shows the railway station to the north of the town in the 1950s. The Carpenters' Arms, a popular hostelry, stands behind. Not a trace of the railway, opened in June 1865, which carried passenger traffic down the valley from Sirhowy (above Tredegar) to Newport, or its station, remains today.

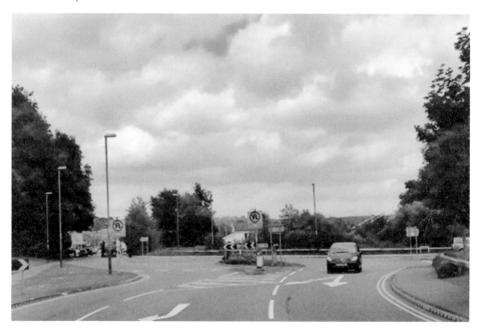

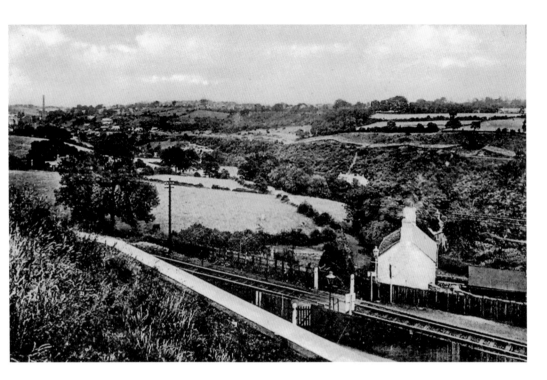

The Chartist Bridge

The view from the top of the steps on Sunnybank Road, looking towards Oakdale. Until this bridge was built, there was always a significant problem in crossing the valley; all the bridges in the vicinity of the town were, and the others still are, single track. The problem was solved by building this impressive cantilever bridge near the sight of the former railway station. The Chartist Bridge opened in 2005.

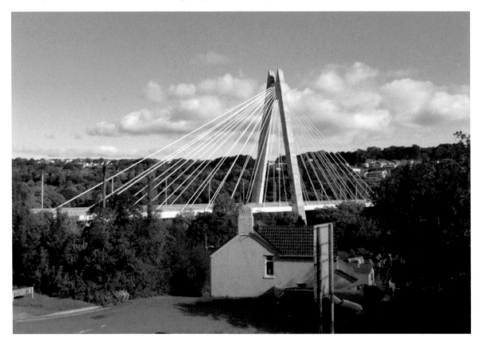

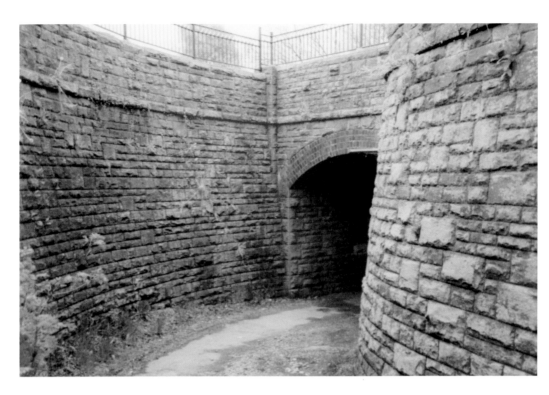

The Stonemasons' Craft

One cannot help but be impressed by the quality of the workmanship produced by the craftsmen of yesteryear. This stonework epitomises those qualities. Each stone in this retaining wall and arch was carefully fashioned more than 150 years ago. Though becoming slightly overgrown, it shrieks quality, the retaining walls sloping backwards at approximately ten degrees to the vertical.

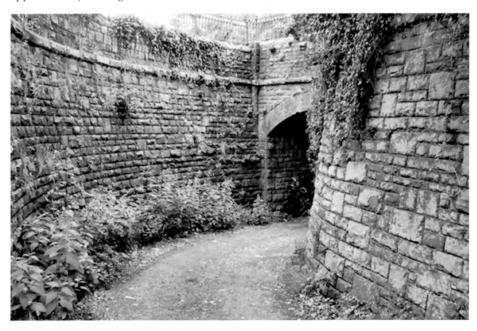

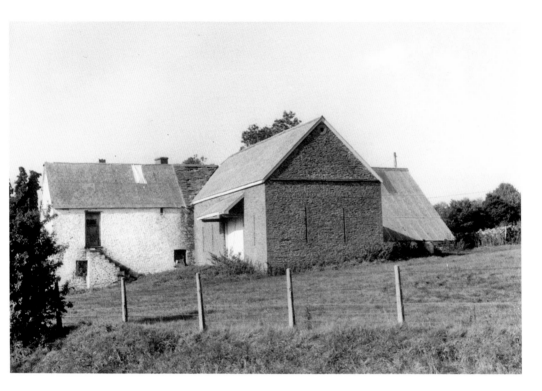

Cwm Gelli Farm

Dating from around 1600, Cwm Gelli Farm is one of the oldest properties in the area. You could stand in the kitchen, look up the chimney, and see the sky. Towards the end of the last century, it fell into a fairly poor state of repair, but has now been taken in hand and turned, together with the barn, into superior living accommodation.

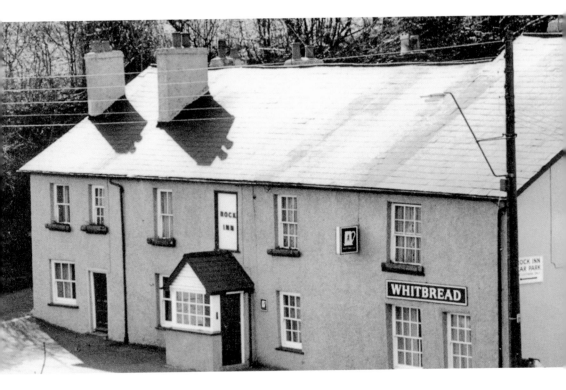

The Rock Inn

The Rock Inn, which now incorporates the cottages that once stood either side of it, is one of the oldest buildings in the area, and is still in use as a hostelry. In times long ago, it was used for parish meetings, petty sessions for the Bedwellty District, for the registration of voters, and for the collection of tithes – that is the tenth part of the produce, income or profits collected from the population for the maintenance of the established church and its clergy.

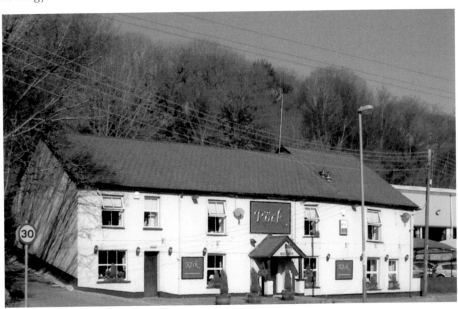

The New Bypass
The upper scene shows the view from the old Woodfieldside railway bridge, as the new road from the Chartist Bridge to the Sainsbury roundabout was being constructed. The yard in the background belongs to Perrys, a local bus company.

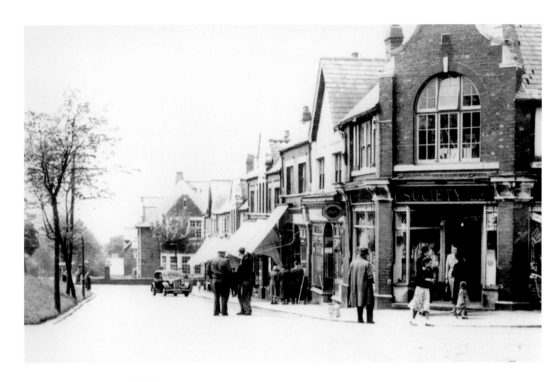

The Square, Oakdale

Shops on the west side of The Square, Oakdale. The local Miners' Institute, opened in 1917, which once stood at the far end and was the focal point of social life in the village, was removed to St Fagan's, where it now stands as an example of a Welsh Miners' Institute. The Institute has been replaced by living accommodation. Some of the businesses shown above have closed and become living accommodation; other units have witnessed a change of use.

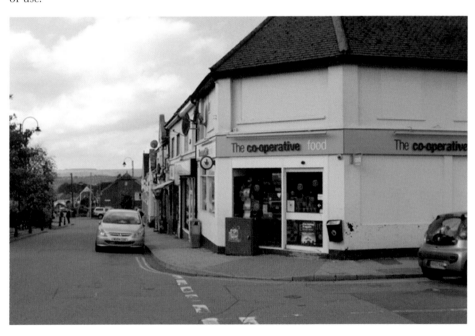

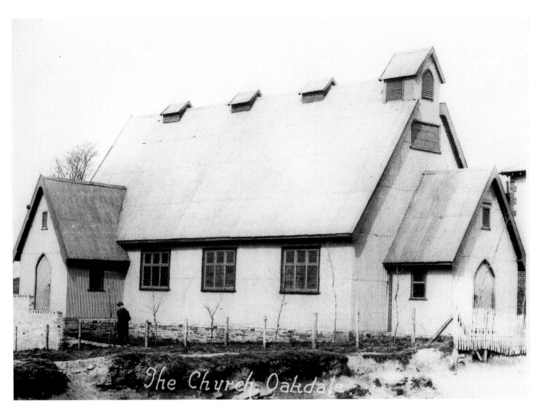

St David's Church, Oakdale

An old picture of the church at Oakdale, a wooden structure covered with corrugated sheeting. The present St David's church is a fine new building with an adjacent parish hall.

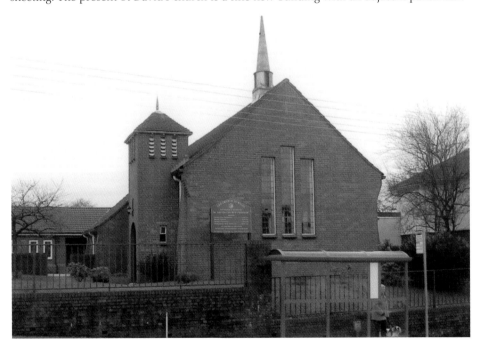

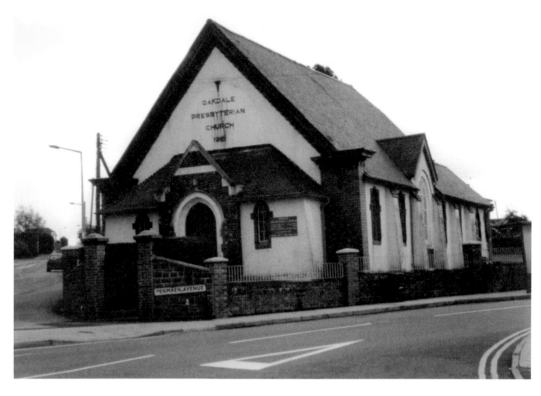

Oakdale Presbyterian Church
Dating from 1916, Oakdale Presbyterian church is situated on the northern side of the village at the junction of Penmaen Avenue and Maes-y-garn. It is an extremely well-maintained building, both inside and out, giving the impression that its members are most caring.

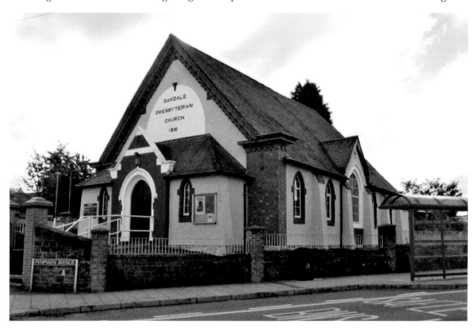

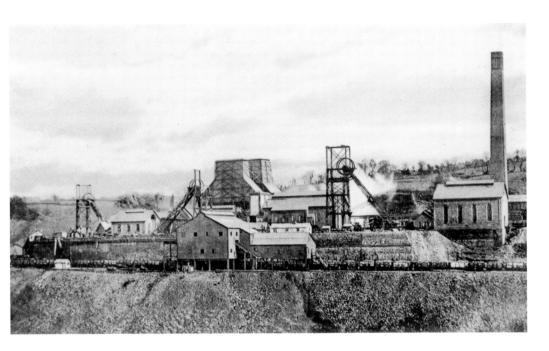

Oakdale Colliery

Oakdale Colliery was opened in 1908 by the Oakdale Navigation Company, a subsidiary of the Tredegar Iron Company. It closed somewhat unexpectedly in 1989 due to unforeseen geological problems, and following significant investment. All that remains are sections of three of the pithead wheels shown below. Three small business units stand on the site today and it is intended to build a new comprehensive school nearby, in place of the comprehensive schools at Blackwood and Oakdale.

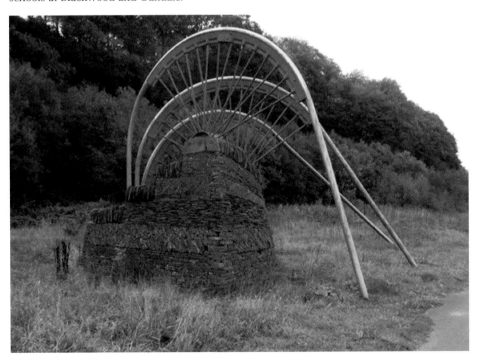

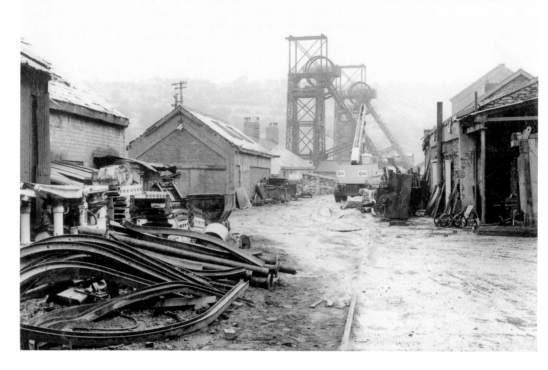

A Commemorative Plaque

The top picture shows two of the three pithead shafts as the structures were being dismantled. The plaque at the side of the pithead wheels shown on the previous page is in memory of those Oakdale Miners who dedicated their lives to the benefit of their nation.

O'R DYFNDEROEDD BYDDED GOLEUNI

PYLLAU GLO
OAKDALE
COLLIERIES
1908 - 1989

OUT OF THE DARKNESS LET THERE BE LIGHT

Er cof y Glowyr o Oakdale wnaeth ymroi eu
bywydau er budd eu Cenedl.

In memory of those Oakdale Miners who
dedicated their lives for the benefit of their Nation.

58

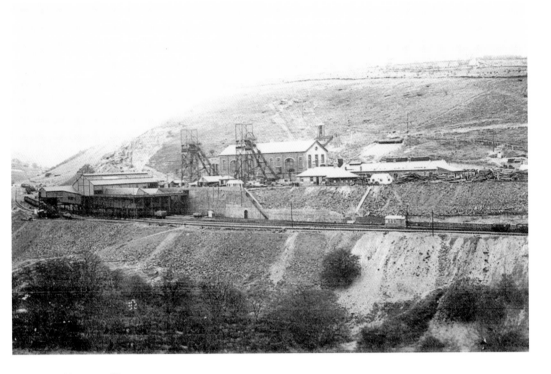

Markham Colliery

Named after Sir Arthur Markham, the company chairman, Markham Colliery was opened in 1912. It was linked underground to Oakdale in 1979, and closed in 1985. Little evidence of the existence of a colliery remains, except for the capped shafts. The village in the background is Hollybush, the lower picture being taken from the high ground of Markham village.

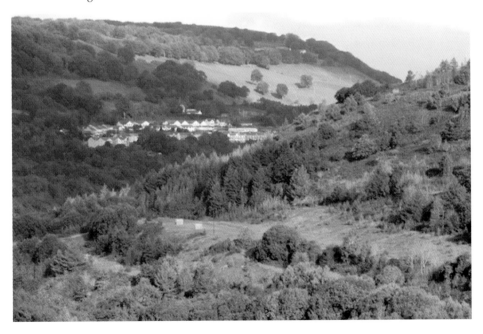

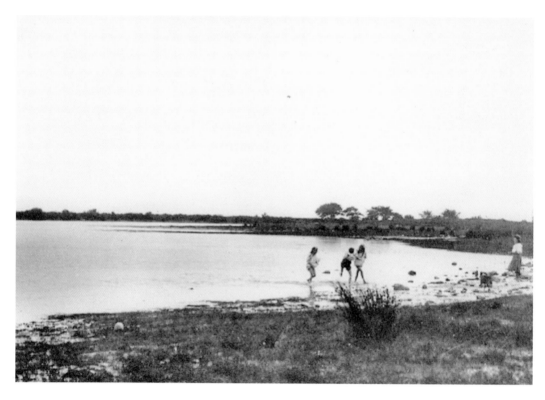

Penyvan Pond

Penyvan Pond was always a popular venue with the local population. Some would swim there and many would picnic. Decades ago the only attraction was the water, but today there is copious parking, a path that circumnavigates the pond, and seats and tables where one can sit and enjoy a drink, an ice cream or snack from the kiosk.

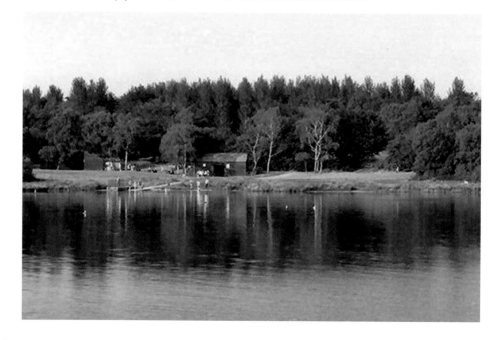

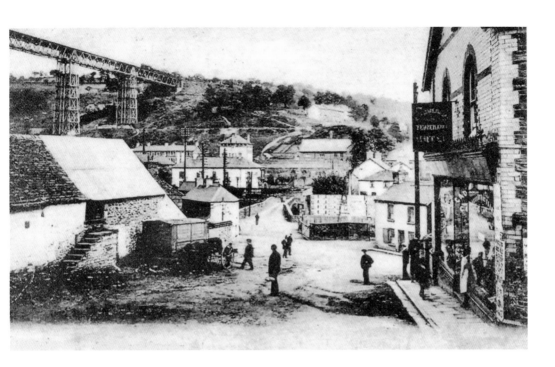

Crumlin Viaduct

A unique iron structure once crossed the valley at Crumlin, allowing trains to travel between Pontllanfraith and Pontypool. Built by T. W. Kennard in 1853–57 at a cost of £62,000, it consisted of seven spans, each 46 metres long and rising to 62 metres at the highest point. The viaduct was demolished in 1965, but the two masonry piers are still visible; one can be seen high up to the left of centre in the lower picture.

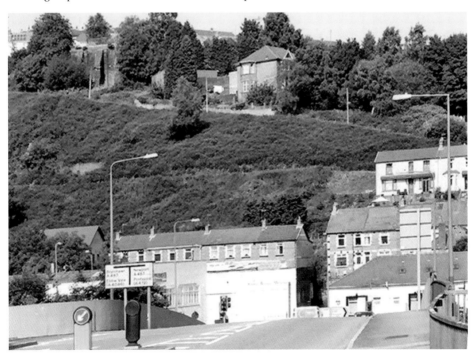

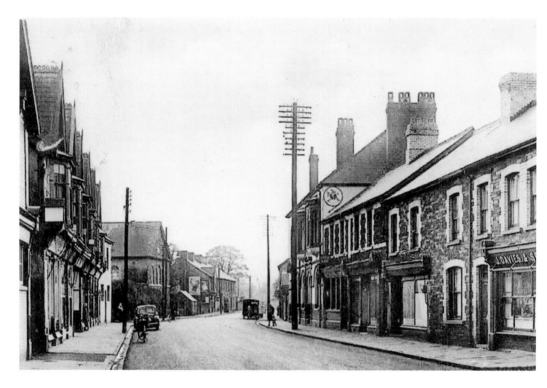

Fleur-de-lis High Street

Many changes have taken place on Fleur-de-lis High Street, as illustrated by these two photographs. The Trelyn Hotel was destroyed by fire in 1999, while opposite Salem Welsh Congregational chapel (built 1860) was taken down in 2000. Some of the shops have closed, but the street is still a thriving shopping area, often densely populated with cars and vans. There is even a butcher's shop, which is more than can be said for Blackwood High Street.

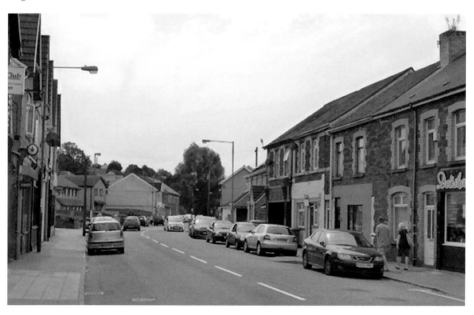

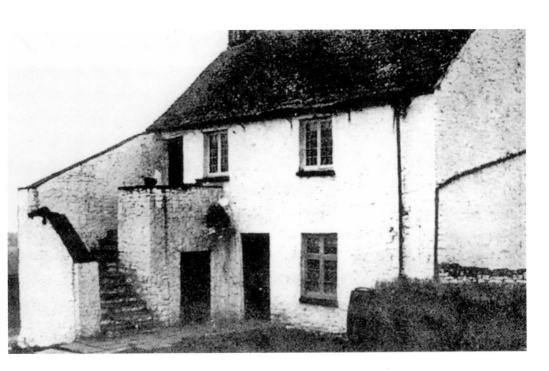

Lewis' School, the Original Buildings

Lewis' School, Pengam, began in the upstairs room of this small house near St Catwg's church, Gelligaer, in 1762. Set up under the terms of Edward Lewis's will of 1715, it provided education for fifteen boys in a room measuring 22 feet by 16 feet, with the master and his family living above. In 1853, a commodious new school, with a chapel for divine worship and a residence for the clergyman, opened for 150 boys and 100 girls on the Pengam site. This impressive building is shown below.

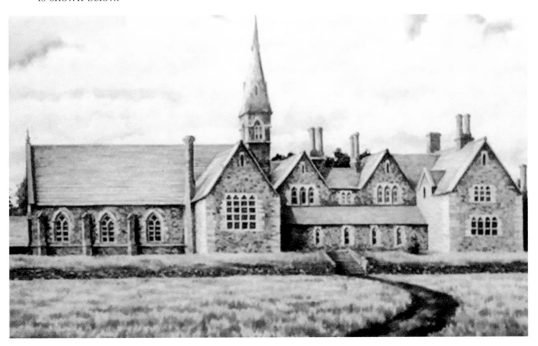

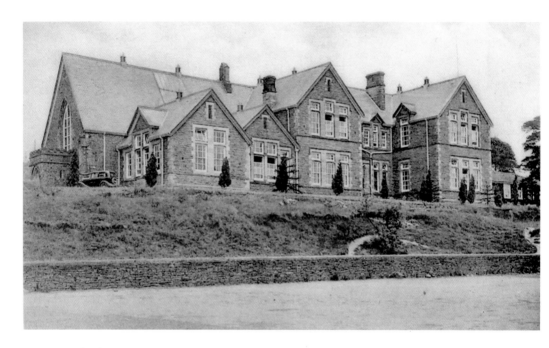

Lewis' School, Pengam, the Modern Buildings

Subsidence, due to coal mining beneath the mid-nineteenth century school, necessitated major rebuilding during the 1902–04 period. The advice from the experts was that the spire should be taken down and not rebuilt, advice that proved most sensible as the new school building, familiar to us all, also suffered terribly from subsidence. It was replaced by a modern comprehensive school, which opened in 2002. It is a strange fact that the old school looked good from the outside but was hardly user-friendly within, whereas the new building is good to work in but cannot be said to look particularly beautiful from the exterior.

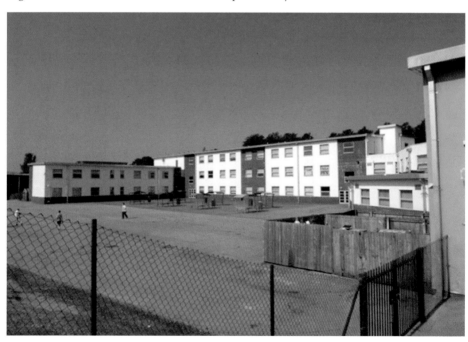

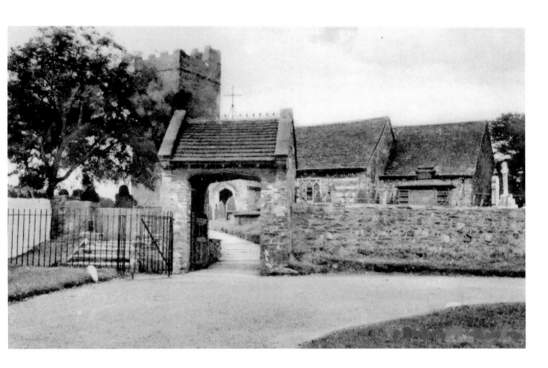

St Sannan's Church, Bedwellty

The hill-top church at Bedwellty, dedicated to St Sannan, is one of the few ancient churches in the county that have changed little since the thirteenth-century building was extended in the fourteenth century. Apart from re-roofing and an external coat of paint in 2002/03, the site remains relatively unchanged externally, apart from the entry arrangements adjacent to the lychgate.

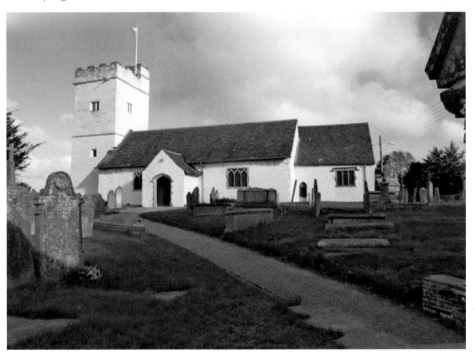

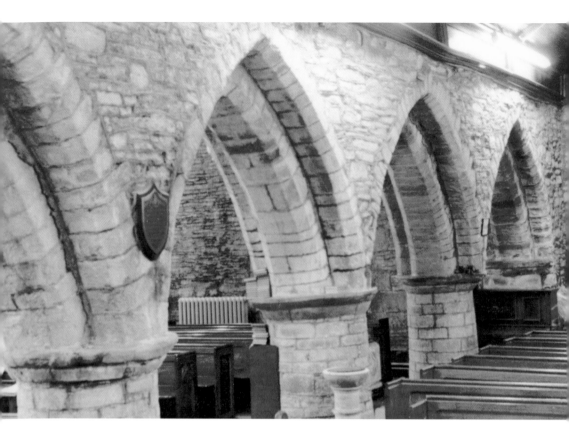

Bedwellty Church, the Interior

Two quite different scenes from the same spot. A completely new roof and ceiling has improved the interior significantly. On the downside, the mason marks on the pier facing the chancel have been obliterated. The interior is now much lighter and some of the pews have been removed and replaced by chairs; this makes the space far more useable.

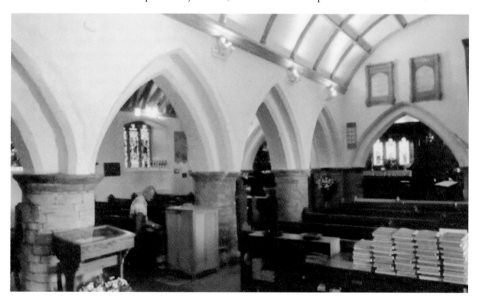

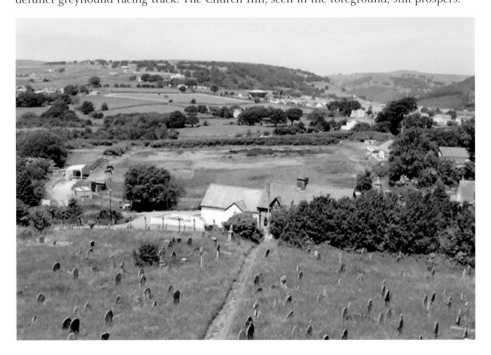

The View from the Tower

On a clear day, there are magnificent views in all directions from the top of the tower at St Sannan's church, Bedwellty. These two photographs, taken looking north, show the now defunct greyhound racing track. The Church Inn, seen in the foreground, still prospers.

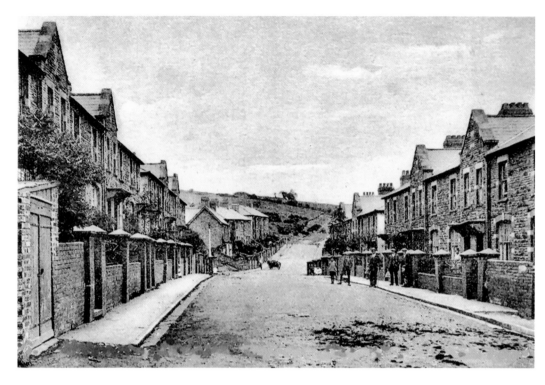

Gelynos Avenue, Argoed

Looking north along Gelynos Avenue towards an unmade Penylan Road, which would eventually lead to Markham village. The triangular tops to the terraced houses gave problems, including the ingress of damp, so were removed many years ago. The small lean-to on the extreme left was where the first Harris buses operated from. The road behind the photographer is a cul-de-sac, serving several new properties.

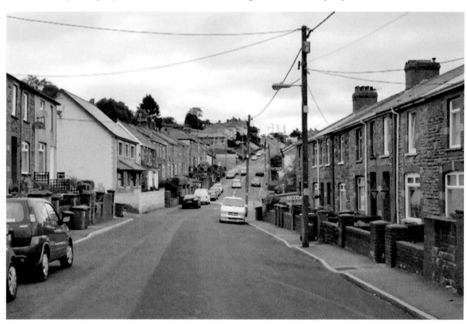

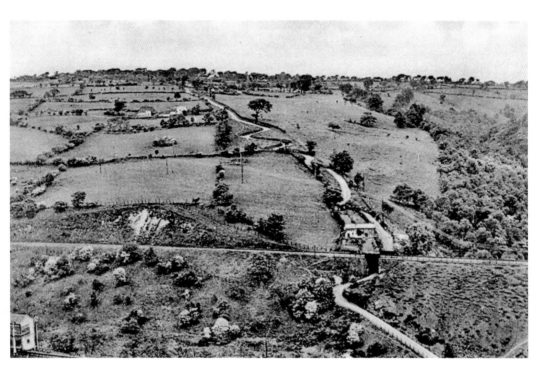

The Road to Manmoel

Shown clearly in the upper photograph is the lane or road that linked the villages of Bedwellty and Manmoel. In the years between the taking of these pictures, the railway lines on both sides of the valley have been removed, and nature has won back much of what had been taken from it by the coal industry.

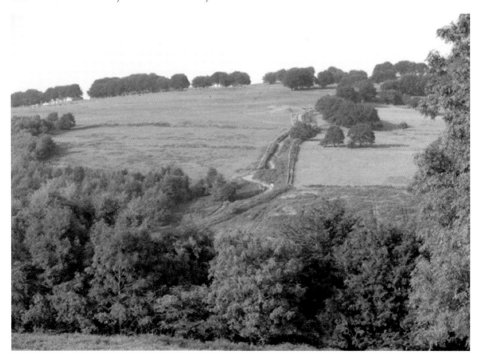

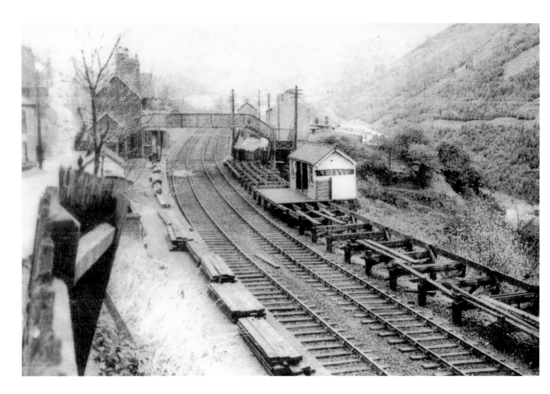

Hollybush Railway Station

Now a private house, the former Hollybush railway station sits squarely in the centre of this picture, with the Hollybush Inn at the foot of Railway Terrace, now a private house, on the left. In the absence of the railway tracks, the occupants of William Street, on the right, have plenty of space to park their cars.

The Southern Cross-Valley Link

The new road from the Chartist Bridge to the Sainsbury roundabout dictated that a cross-valley link should be built south of the town. Shown here in construction and again in 2013, the road links the traffic-light-controlled junction at Libanus, with the roundabout at Woodfieldside.

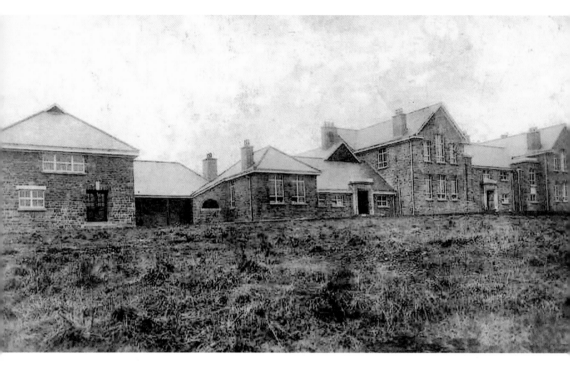

Pontllanfraith Grammar School

In 1923, the Tredegar group of managers planned to open a central school at Pontllanfraith, to prepare children for a life of active labour and social cooperation. By 1926, when the school opened, it had been decided that it should be a grammar school. The first entry comprised forty-nine pupils who thought they would go either to Tredegar or Newbridge, plus thirty-nine who sat an entrance examination. Pontllanfraith was roughly halfway between the grammar schools at Tredegar and Pontywaen, and was sited at an important rail junction; the north–south and east–west railway lines crossed a short distance from the school.

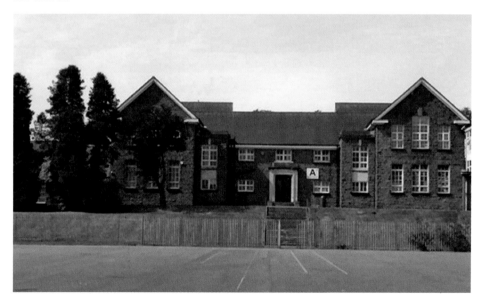

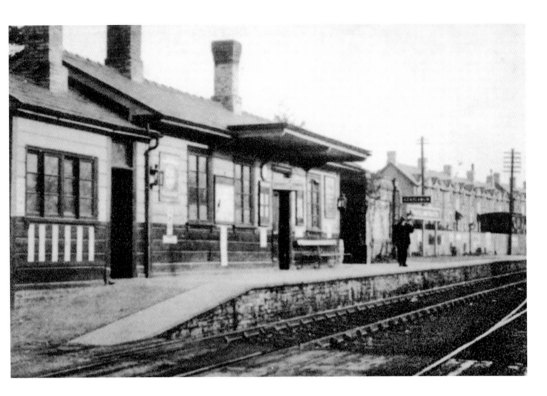

Pontllanfraith Top Station

Known as Tredegar Junction until the name was changed in 1911, Pontllanfraith Top station was on the line from Tredegar to Newport. This line opened in 1865, but celebrations were abandoned because of a disaster at Bedwellty Pits Colliery, where twenty-six men were killed and many injured. The terrace of houses in the background is almost unchanged.

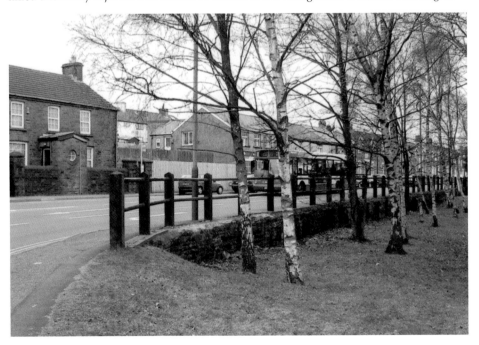

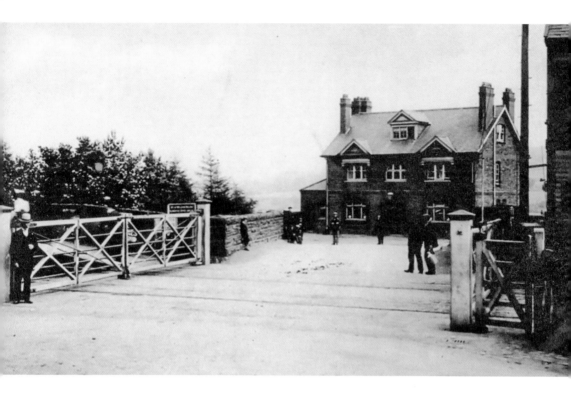

The Junction Hotel, Pontllanfraith

This level-crossing, overlooked by the Junction Hotel, guarded traffic from trains on the Tredegar–Newport line. Its name was chosen because it overlooked the top station, but was just a few hundred yards from the Pontllanfraith station on the Pontypool–Hengoed line.

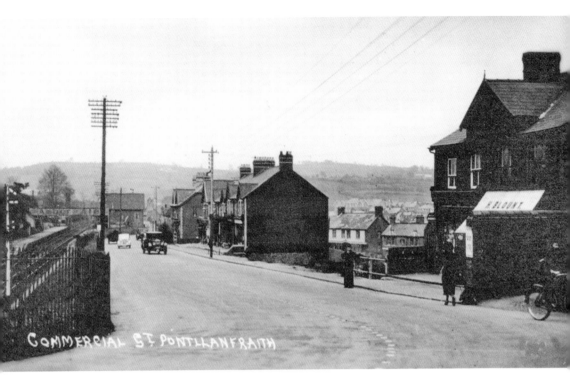

Towards Pontllanfraith Bottom Station

Looking north from the Junction Hotel towards Pontllanfraith Bottom station. The Pontypool–Hengoed line is no more. In its place, the local authority has been able to construct a few hundred yards of dual carriageway.

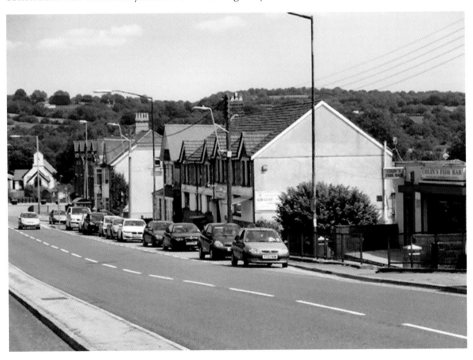

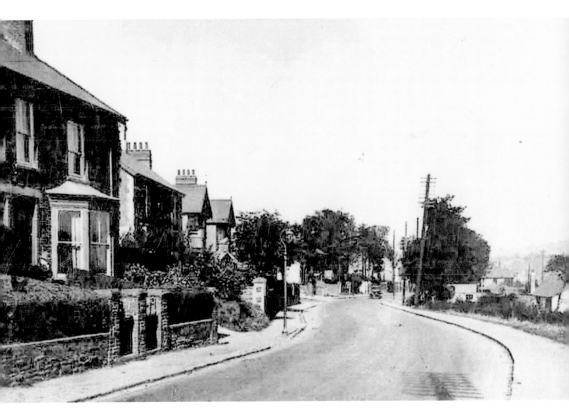

The Bird in Hand
The curve in the road at the Bird in Hand corner, Pontllanfraith. Yet again, nature is doing a very good job at reclaiming what was once taken away from it. Today, the public house still functions but is hidden behind the trees.

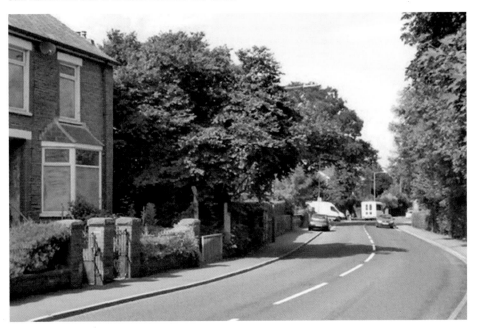

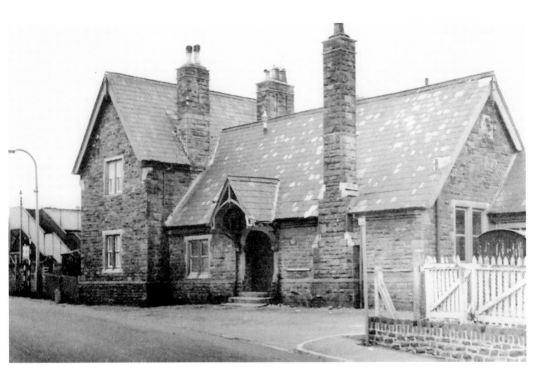

Pontllanfraith Bottom Station

This is the station where Sir Julian Hodge began his working life as a railway clerk. The former railway company ground to the right now provides St Augustine's church with a sizeable car park.

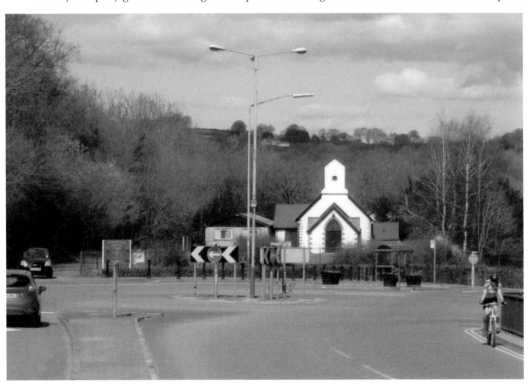

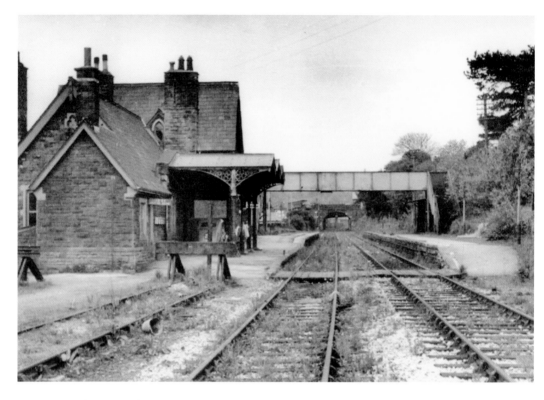

Towards the Level Crossing, Pontllanfraith
Looking south from Pontllanfraith Bottom station. In the foreground is the passenger footbridge and in the distance, the road bridge carrying traffic on the main road in front of the Junction Hotel. The dual carriageway offers adequate parking on both sides of the road.

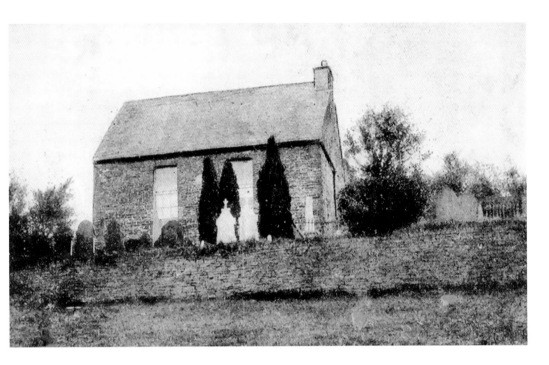

Twyn Gwyn Chapel

This chapel was built in 1829 by members of the Baptist faith who had differences with other Baptist groups in the area. By the 1860s, there was a membership of about sixty, and a thriving Sunday school. Several other Baptist churches were founded by members of Twyn Gwyn, including English and Welsh chapels at Cwmfelinfach, and Elim in Pontllanfraith. As the years passed, membership in this isolated spot declined and the church eventually closed. It stood empty for years and was vandalised, but in the 1990s it was taken in hand and converted into a pleasing private house with magnificent views across the valley.

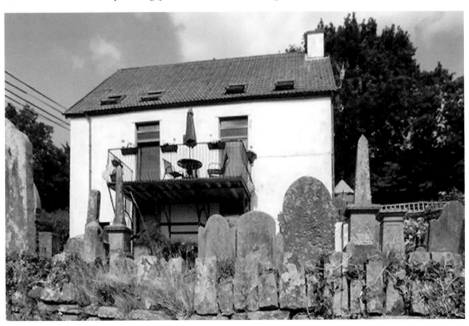

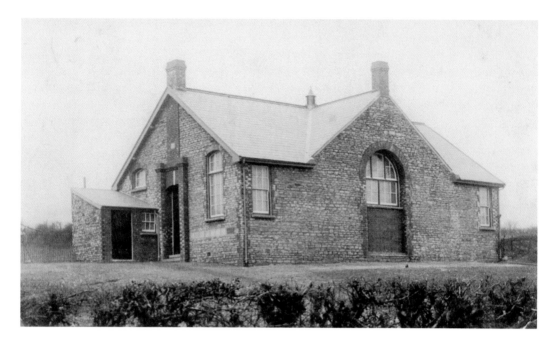

Elim Baptist Chapel, Pontllanfraith

In 1869, the members of Twyn Gwyn chapel built a school room at Pontllanfraith and called it Elim. In 1891, the members who met at Elim decided to separate from those at Twyn Gwyn and form their own church. They met in a building near the entrance to Pontllanfraith Welfare Ground, but moved to the present site on Newbridge Road, Pontllanfarith in 1912. In more recent times, the building has been enlarged and updated.

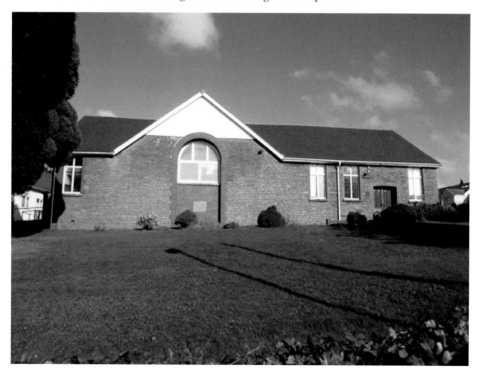

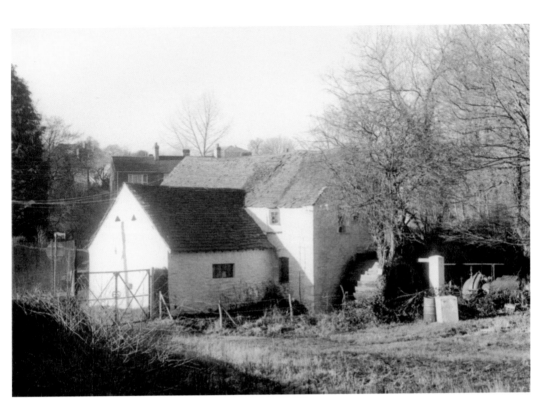

The Mill, Gelligroes

This is the spot from which the first radio signals were transmitted and received in the area. One very important message in 1912 was from the sinking *Titanic*. The 12-foot-diameter waterwheel was of the overshot type, with rim buckets using water funnelled from the Sirhowy river. A Victorian postbox rests in the west wall.

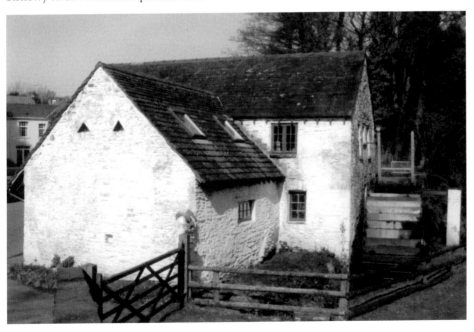

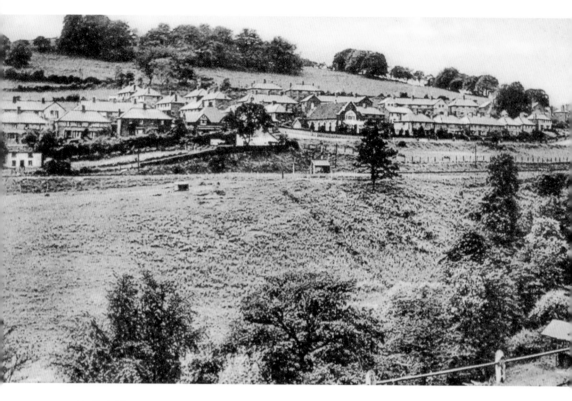

Wyllie Village

The village of Wyllie, with its accompanying colliery, was named after Lt-Col. Alexander Wyllie, a Cambridge barrister who was also a director of the Tredegar Iron Company and the Oakdale Navigation Collieries Ltd. The colliery opened in 1926 and closed in 1967.

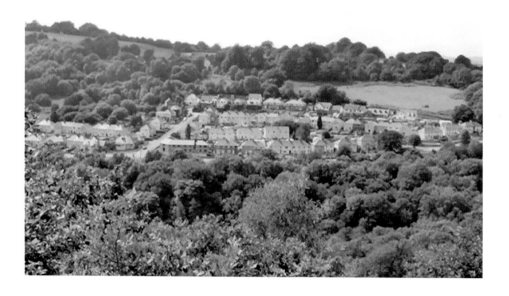

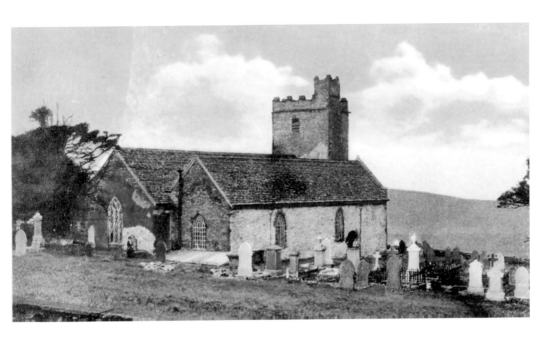

St Tudor's Church, Mynyddislwn

There has been a church on this site since at least the twelfth century. Major rebuilding around 1819–22 almost doubled the seating with the addition of a north aisle. Further change took place around 1907 when the floor was lowered, the high-backed pews replaced by chairs, and a new barrel-vault ceiling installed in the north aisle. Other planned work, including extensions to the chancel and north aisle, had to be abandoned, possibly because the local lady who had agreed to pay part of the cost changed her mind when she learned that soil removed from the inside of the church and scattered on a nearby field contained human remains. Further restorative work was undertaken in 2000.

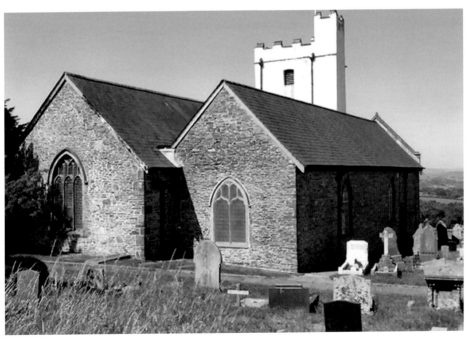

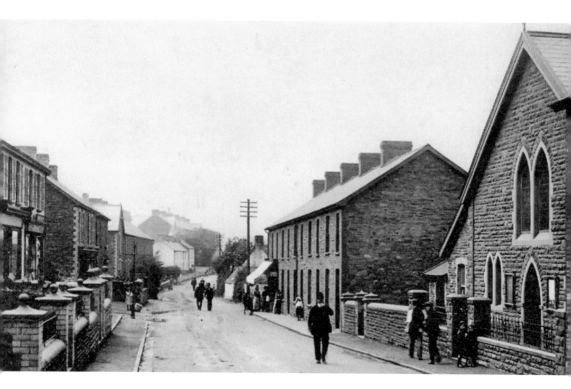

Pentwynmawr High Street

Looking west from the junction of High Street with Fox Lane. The Presbyterian chapel, which is as old as the village itself, stands to the right. An unusual sight comparing the two scenes is that houses have been turned into shops rather than vice versa.

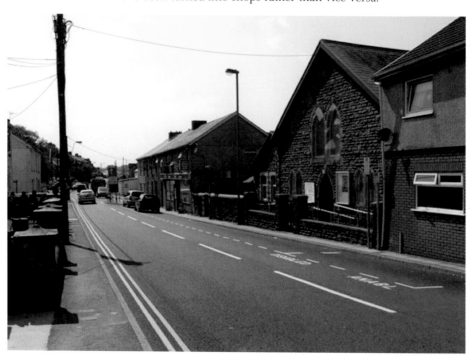

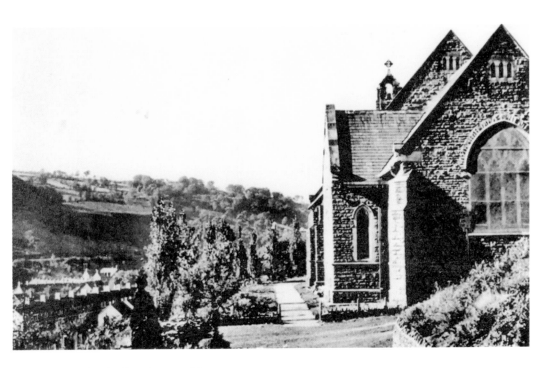

St Theodore's Church, Ynysddu

As a result of the Welsh Church Act of 1914, the Church in Wales separated from the Province of Canterbury in 1920. A consequence was that new parishes were set up, including the parish of Ynysddu, which included the two villages of Cwmfelinfach and Ynysddu. The first new parish church was a wooden structure covered with corrugated sheeting, but an impressive new church was founded in 1925 and consecrated two years later.

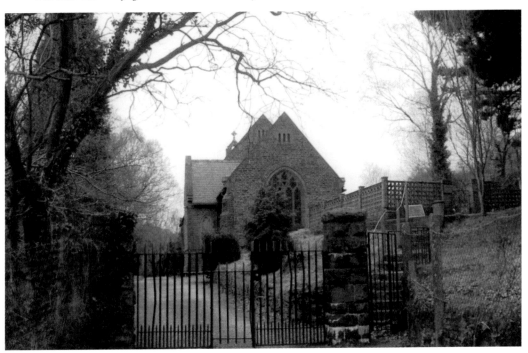

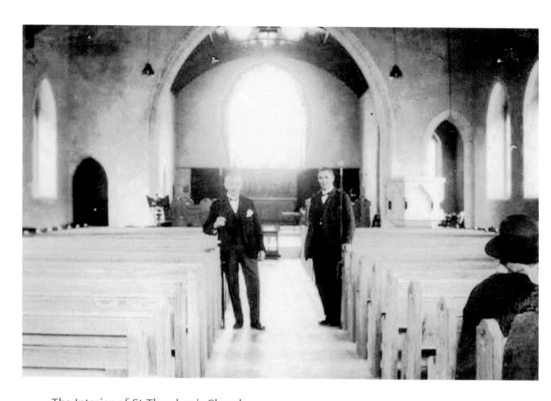

The Interior of St Theodore's Church

This early photograph shows the interior of St Theodore's and the two church wardens the year it was opened, and before the pews had been stained. Today this beautiful, well-preserved church will seat around 300 people.

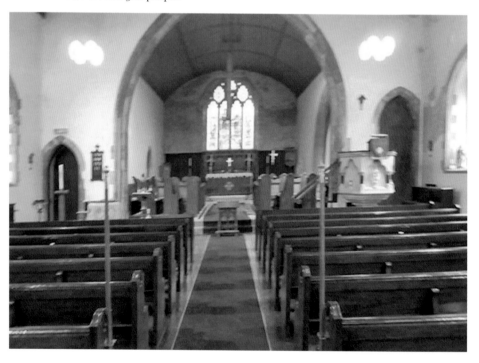

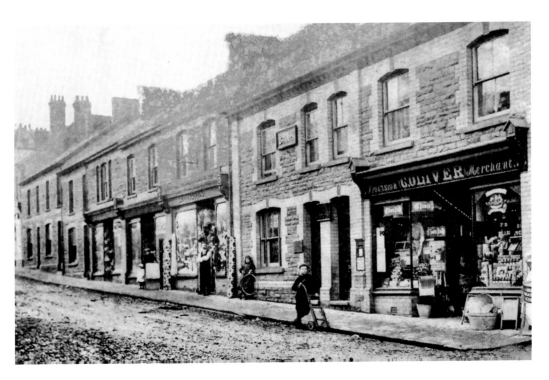

Maindee Road, Cwmfelinfach

The shop of provision merchant G. Oliver looks out on the unmade road in Maindee Road, Cwmfelinfach. Next door is the National & Provincial Bank, with a postbox between the two properties. Compared with today, two of the other shops have been converted into living quarters, but further along the reverse has taken place.

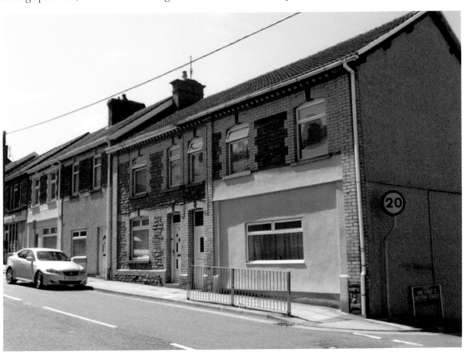

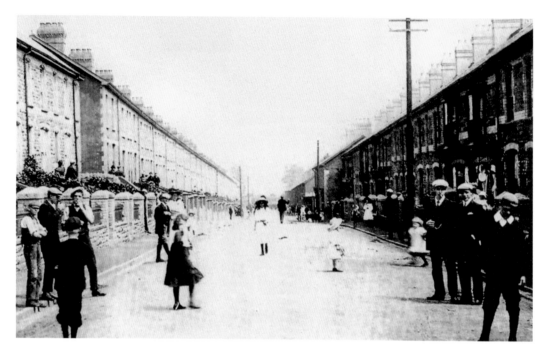

Islwyn Road, Wattsville

Adults converse and children play at the bottom of the hill from Brynawel to Risca. Was this photograph taken on a Sunday for so many people appear well dressed? There were no double yellow lines, nor were there traffic calming measures in those days; so unlike the present day!

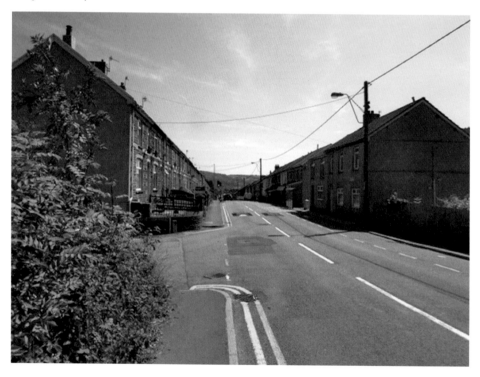

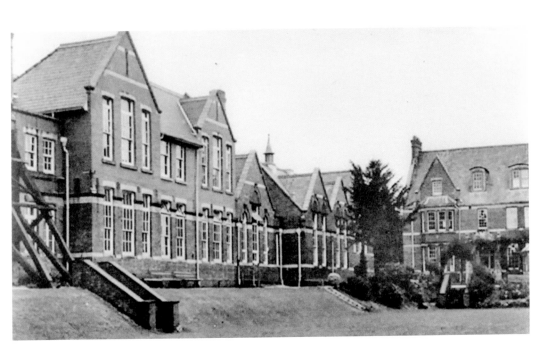

Lewis Girls' School, Hengoed

Hengoed Girls' County School was formally opened at Hengoed on 1 Novemeber 1900. Girls had first been educated under the terms of Edward Lewis's will at Pengam in 1853, but by 1882 the governors had established a separate school for them at Pontlottyn. Forced closure resulted in a new school being built at Hengoed. Here, the girls remained until subsidence forced another move, this time to Ystrad Mynach in 1959, when the name was changed to Lewis Girls' Grammar School. This name remained until the nationwide changes of the 1960s and 1970s, when it became Lewis Girls' Comprehensive School.

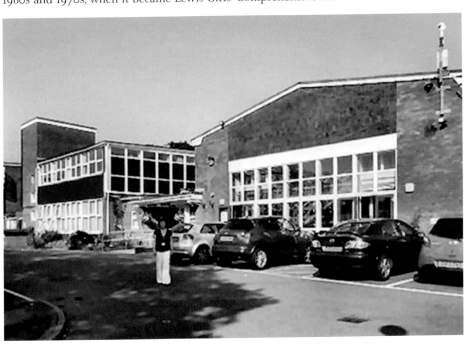

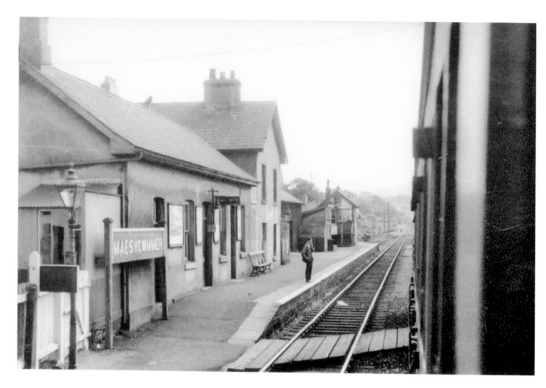

Maesycwmmer Station

The view from Maesycwmmer railway station looking towards Caerphilly. The station was on the Brecon and Merthyr line to Newport. It passed beneath Hengoed viaduct, from which the lower picture was taken.

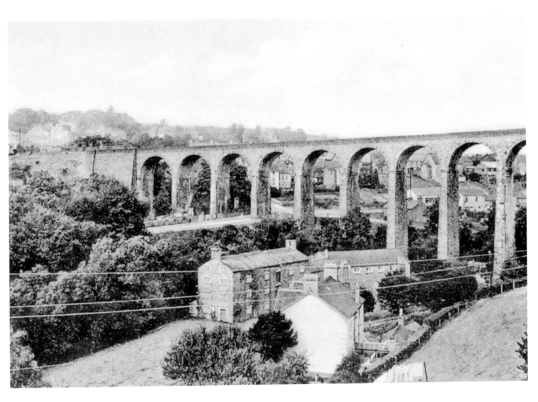

Hengoed Viaduct

The viaduct, which still links Hengoed and Maesycwmmer, was built to carry a double railway track connecting Neath and Pontypool. It is a magnificent structure rising some 260 metres above the valley floor.

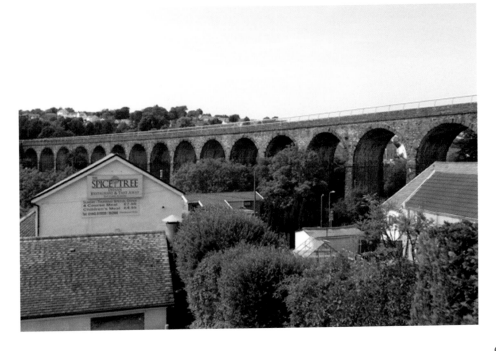

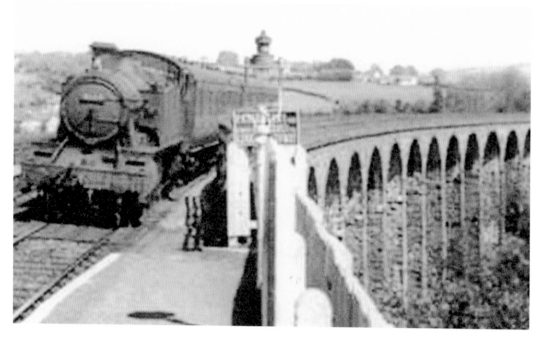

The Gren Trail

Taken looking east along the length of the viaduct, these pictures show how it was wide enough to carry twin railway tracks across the Rhymney Valley, and how it is suitable for pedestrians and cyclists today. Closed in 1964, it is now part of the Gren Trail, named after the famous cartoonist who was a native of Hengoed.

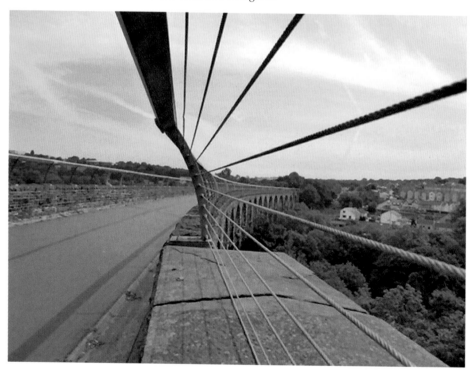

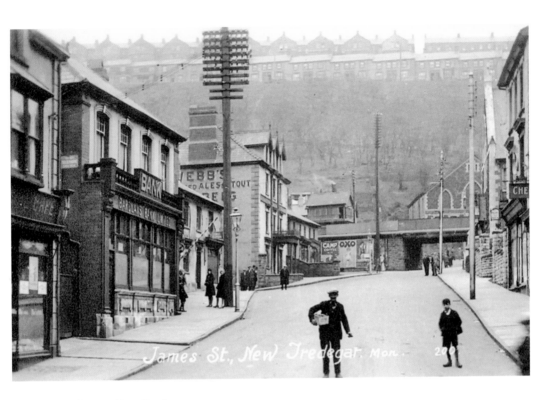

James Street, New Tredegar

A great deal has changed in this scene over the years. The low railway bridge and chapel behind it have been demolished, Barclays Bank has closed, as has John Price & Sons, drapers. The Parish Hall is now divided between a photographer and a small engineering business, while the building on the extreme left was taken down years ago. The houses belonging to Phillipstown are still there, but are now totally hidden behind the trees.

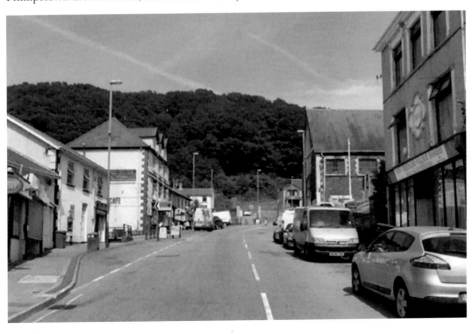

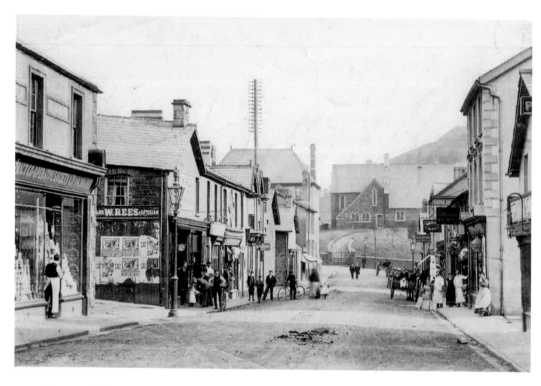

Commercial Street, New Tredegar
What was once a busy street of shops is now fairly quiet. The photographer is looking south towards the Church in Wales parish church of St Dingat's.

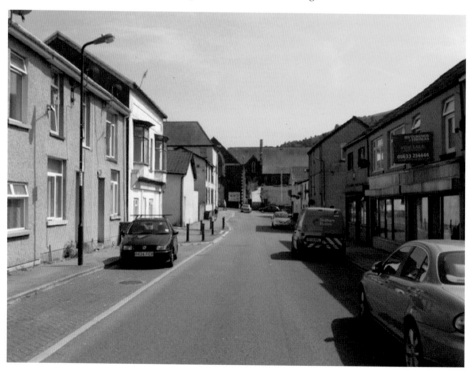

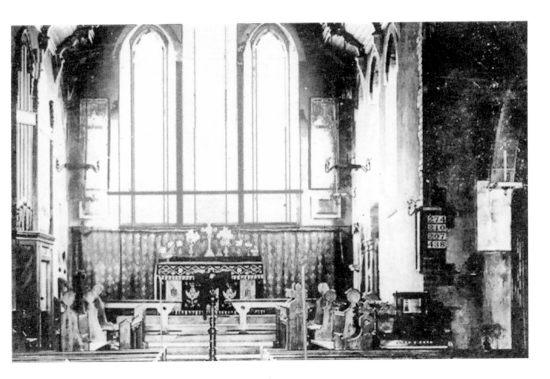

St Dingat's Church, New Tredegar

St Dingat's was built of pennant sandstone in 1892/93. This picture shows the chancel in the early days. The impressive chancel screen shown below was the gift of John Price, the draper, who lived next to the church, and was a one-time church warden. It was erected in 1928 in memory of his daughter Elizabeth Mary Price, who died in 1923 at the tender age of twenty-one.

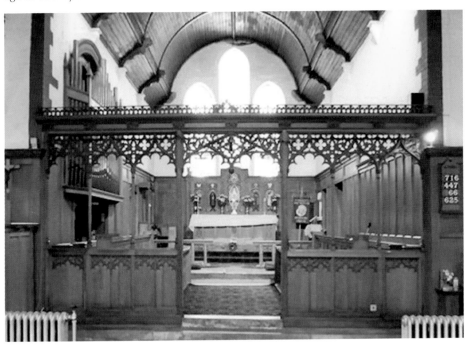

Acknowledgements

Very many people have helped with the production of this book by allowing me access to various buildings, making useful suggestions and furnishing me with information and old photographs. I am most grateful to Peter Downing, Doug Gilchrist, Pat and Arthur Jenkins, Peter and Brenda Jones, Sian Mainwairing, Trevor Morgan, Mike Perry, Delyth Robinson, Cliff Sharp, Tony White and Lyn Wilstead. In particular, I would like to thank my wife Betty and good friends John Watkins and Gethin Morgan for reviewing the work at various stages and making many useful suggestions.

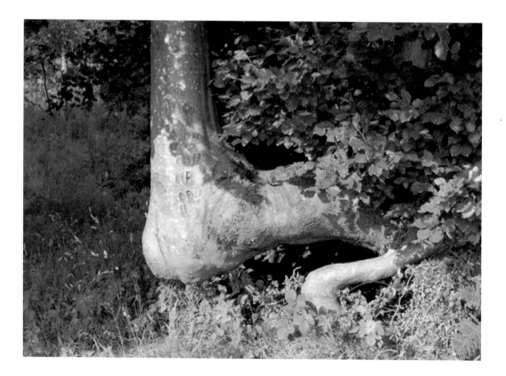

The Heel Tree, Penyvan
A most unusual tree is found in the boundary between the pond and the road at Penyvan. Called the Heel Tree, there is no support under the 'heel', and one wonders what its history can be to have become such an unusual shape.